THE
SUMMER
CANADA
BURNED

With contributions from Postmedia journalists:

DAN BARNES	ALLISON HANES	ELIZABETH PAYNE
MATTHEW BLACK	GORDON HOEKSTRA	DERRICK PENNER
DAVID BLOOM	ADAM HURAS	JULIA PETERSON
LAUREN BOOTHBY	HAMDI ISSAWI	BRAD QUARIN
JOSEPH BREAN	LISA JOHNSON	ARLEN REDEKOP
RENÉ BRUEMMER	NAIMUL KARIM	MICHAEL RODRIGUEZ
SHAUGHN BUTTS	BILL KAUFMANN	SUSAN SCHWARTZ
CHERYL CHAN	JOANNE LAUCIUS	KIMIYA SHOKOOHI
TIFFANY CRAWFORD	MICHELLE LALONDE	GREG SOUTHAM
LORI CULBERT	GLENDA LUYMES	PETER J. THOMPSON
DOUG CUTHAND	DARREN MAKOWICHUK	CINDY TRAN
TYLER DAWSON	HIREN MANSUKHANI	CHRIS VARCOE
KATIE DEROSA	VINCENT MCDERMOTT	JONNY WAKEFIELD
DARREN FRANCEY	GORDON MCINTYRE	JIM WELLS
AZIN GHAFFARI	JULIE OLIVER	GAVIN YOUNG
SARAH GROCHOWSKI	BRYAN PASSIFIUME	

 POSTMEDIA

 GREYSTONE BOOKS
Vancouver/Berkeley/London

A BOOK FROM POSTMEDIA AND GREYSTONE

(Photo on facing page courtesy Communications Nova Scotia)

THE
SUMMER
CANADA
BURNED

THE WILDFIRE SEASON
THAT SHOCKED THE WORLD

MONICA ZUROWSKI | POSTMEDIA

Greystone Books Ltd.
greystonebooks.com

Cataloguing data available from Library and Archives Canada
ISBN 978-1-77840-187-9 (cloth)
ISBN 978-1-77840-188-6 (epub)

Content in this book is based on the work of Postmedia journalists
across Canada. Thanks to the Canadian Press, Nova Scotia Communications,
SOPFEU, the Ontario Ministry of Natural Resources & Forestry,
Alberta Wildfire, and Chris Schneider for usage of additional photos.

Editing and proofreading by Tracy Bordian
Cover and interior design by Jessica Sullivan
Cover photo by Scott Wiseman,
Ontario Ministry of Natural Resources and Forestry

Printed and bound in Canada on FSC® certified paper at Friesens. The FSC® label
means that materials used for the product have been responsibly sourced.

Greystone Books thanks the Canada Council for the Arts, the
British Columbia Arts Council, the Province of British Columbia
through the Book Publishing Tax Credit, and the Government
of Canada for supporting our publishing activities.

Greystone Books gratefully acknowledges the xʷməθkʷəy̓əm (Musqueam),
Sḵwx̱wú7mesh (Squamish), and səlilwətaɬ (Tsleil-Waututh) peoples on
whose land our Vancouver head office is located.

(Photo on facing page courtesy Communications Nova Scotia)

FOR THE FIREFIGHTERS AND
FIRST RESPONDERS WHO LOST
THEIR LIVES KEEPING US SAFE.

FOR THE THOUSANDS OF
OTHER PERSONNEL WHO
BATTLED THE BLAZES.

FOR THE HUNDREDS OF PEOPLE
WHO LOST THEIR HOMES.

FOR EVERYONE
WHO WAS FORCED TO FLEE.

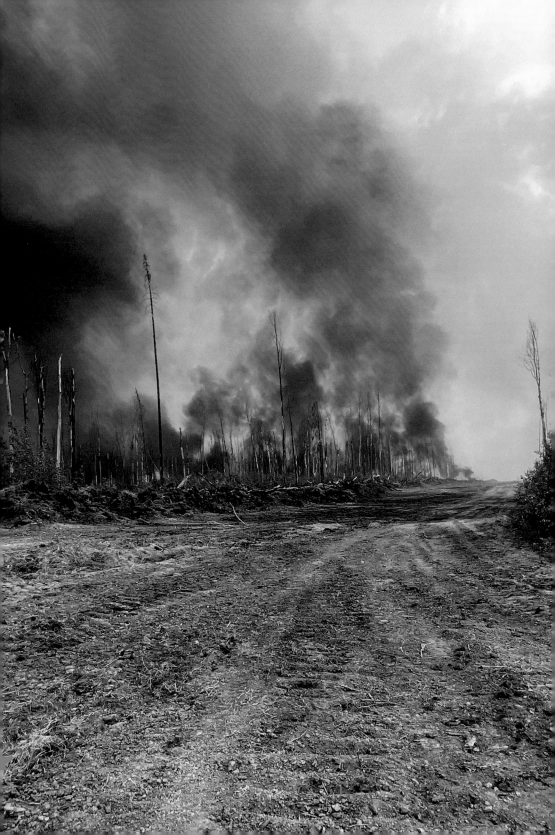

CONTENTS

(Photo on facing page courtesy Alberta Wildfire)

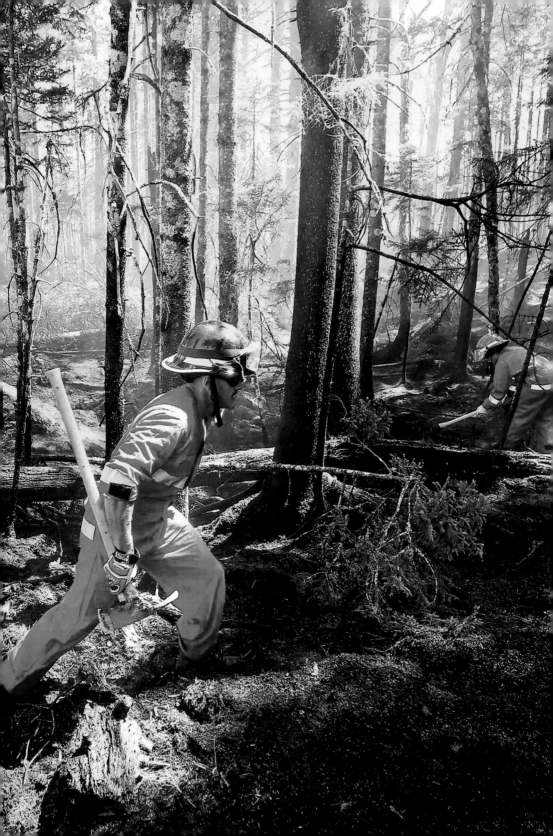

INTRODUCTION
A NATION ON FIRE

A **CALM PREVAILED BEFORE** the firestorm. Canada awaited the start of wildfire season. It was the end of April. The annual battle of the blazes was not expected to begin in earnest for weeks, maybe even two months in a good year. But it would soon become clear that the 2023 season would be anything but good.

On April 30, the first "wildfire of note"—meaning it could threaten public safety or critical infrastructure—popped up in Alberta. About an hour's drive west of the capital city of Edmonton, near the hamlet of Entwistle, a fire devoured tinderbox-dry trees and grass. A few minutes away, a second wildfire of note burned simultaneously. This one cropped up closer to the hamlet of Evansburg, humorously known for electing a "town grouch" in past years. There was nothing funny, however, about what was about to occur: Something had sparked Alberta's first two notable fires of the year, igniting a wildfire season across Canada unlike any other.

The blazes became a fiery harbinger, foreshadowing a season eventually described as *vicious*, *hellish*, and *apocalyptic*. One word, however, emerged from the lexicon of forestry experts as the defining characteristic of the 2023 Canadian wildfire season: *unprecedented*.

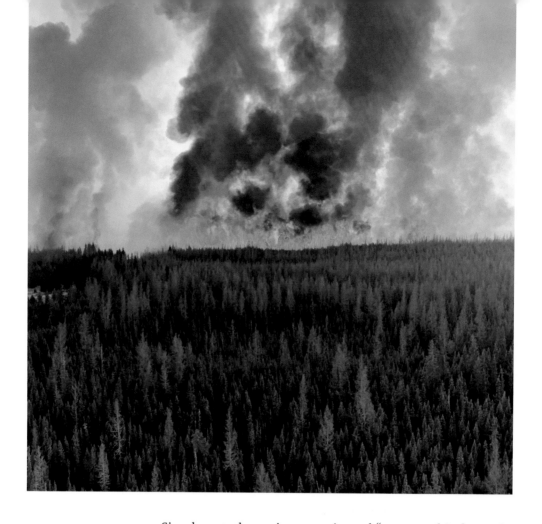

Simply put, the nation experienced "catastrophic fire activity," said Yan Boulanger, a research scientist at the Canadian Forest Service, Natural Resources Canada. "This fire season has been marked by extreme fire weather conditions driven by record high temperatures and widespread drought conditions across the nation," Boulanger said. It was "the most devastating fire season in recent memory, by far."

By the end of September, the amount of Canadian forest lost to destructive flames sat at 18 million hectares (44.4 million acres). That represents an area bigger than 140 of the world's countries. It's also about six times greater than the

average amount of land lost to fire in an entire season in Canada. Frighteningly, the season was still a few weeks away from being over, with more than 480 fires still burning out of control when that tally was made.

"This is a scary time for a lot of people from coast to coast to coast," said Canada's Prime Minister Justin Trudeau, alluding to the vastness of a nation on fire, stretching from the Pacific to the Atlantic oceans and upward into Canada's north.

Tens of thousands of Canadians had faced evacuation orders and been chased from their homes by flames—some with only their kids, their pets, and the clothes on their backs. They anxiously awaited news in a haze-filled limbo, hoping for permission to return home and dreading the outcome that hundreds faced: They no longer had a home to go to.

"The stress of leaving your home, not knowing if it will be there when you return, is a reality now faced by thousands," said Harjit Sajjan, the federal Minister of Emergency Preparedness. "It is during these dark times that we see our country come together."

WILDFIRE WARNINGS ARRIVED from a myriad of forestry and government agencies, as a hot, dry spring gave way to an even hotter, drier summer. Dozens of communities sat on the verge of fire disaster, with unrelenting heat baking the boreal forest.

"This weather event has the potential to be the most challenging 24 to 48 hours of the summer from a fire perspective," Cliff Chapman, director of wildlife operations with the BC Wildfire Service, said at one point. "If there was ever a time to make sure you have an evacuation plan for you and your family, it's now. If ever there was a time to make sure you have a grab-and-go bag, it is now."

Canada's summer of fires

Canada has never experienced a worse year for wildfires. These snapshots show the fire situation on Sept. 6 of this year, as compared to 2022, a more typical fire year. More than 6,100 wildfires have burned 16.5 million hectares — an area nearly as large as the state of Wisconsin.

● Out of control ○ Being held ● Under control

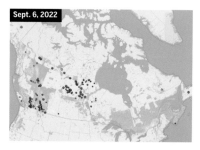

Sept. 6, 2022

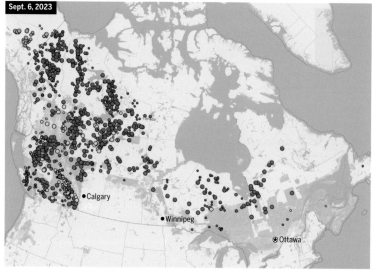

Sept. 6, 2023

Calgary

Winnipeg

Ottawa

Sources: Canadian Wildfire Information System / Natural Resources Canada

Darren Francey / Postmedia

His words fit the narrative of the wildfire season. Never before had Canada seen this many wildfires that were this large, this intense, and this fast. The superlatives stacked up as flames gutted forests across almost all of Canada's 10 provinces and 3 territories throughout the summer. Some provinces recorded the largest wildfires they had ever experienced. Others recorded more fires than ever before. Still others saw fires travel at unparalleled speeds.

Just how unprecedented was Canada's 2023 fire season? Well, the wildfire destruction was off the charts—literally.

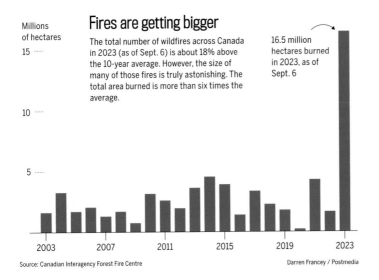

Fires are getting bigger

Millions of hectares

The total number of wildfires across Canada in 2023 (as of Sept. 6) is about 18% above the 10-year average. However, the size of many of those fires is truly astonishing. The total area burned is more than six times the average.

16.5 million hectares burned in 2023, as of Sept. 6

15

10

5

2003 2007 2011 2015 2019 2023

Source: Canadian Interagency Forest Fire Centre

Darren Francey / Postmedia

Officials whose job is to track wildfires needed to create new charts to show the dramatic increase in land lost to fire in 2023.

With more than a quarter of the fire season still left, 6,230 wildfires had roared across the country by September 10. In 2022, there were 4,883 such fires in the entire year.

The intensity of the fires shocked many Canadians, too. British Columbia experienced a rare "firenado"—a whirling vortex of flames that sucks in debris. Evacuees across the country reported that the heat of wildfires peeled paint off their vehicles as they dashed for safety. Fires burned so deep in parts of the forest that they left roots exposed, leaving trees with an other-worldly appearance of being suspended in air. And no structure in the path of a wicked wildfire was safe—including the firehall that became engulfed in flames in the town of Scotch Creek, B.C., or the homes of 13 firefighters who battled to save their tiny community of Wilson's Landing, B.C., while their own houses were gutted.

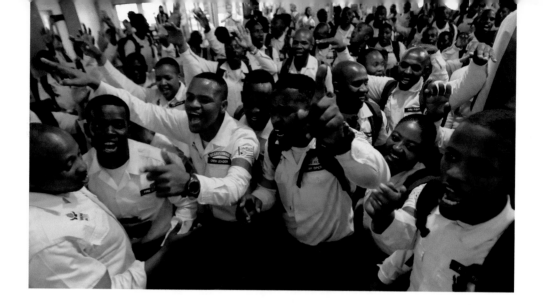

The 2023 wildfire season was indeed unparalleled, said the Canadian Interagency Forest Fire Centre (CIFFC), a non-profit corporation owned by Canada's federal, provincial, and territorial wildland fire-management agencies.

"What has demarcated this season is that we had significant fire activity in different places simultaneously and that has really made for some challenging conditions," said Jennifer Kamau, CIFFC communications manager.

Each wildfire season, CIFFC monitors the country's fire activity, the availability of firefighting resources, and the demand for those resources. The organization then gives the country a rating of 1 (the best-case scenario) to 5 (the most critical scenario) on a national preparedness level. In spring 2023, it moved Canada to a 5 very early in the season, on May 12. The country remained on that highest level of alert all summer. While hitting a Level 5 isn't rare, the duration for which Canada sat at this level is, said Kamau. A Level 5, she explained, means "[that] there's significant fire activity in one or more jurisdictions; that firefighters and equipment in Canada have all been put to use; and that we've requested international help."

Canada, indeed, needed help.

LOST IN THE TURMOIL of wildfire destruction is the fact that fire exists as a natural part of the ecosystem. It eliminates dead trees, turns past-its-prime organic material into ash, and opens up swaths of ground, allowing new life to access nutrients from the soil and restart the cycle of forest life. While lightning is often a precursor to such events, forest-management folks also use controlled or prescribed burns to foster vegetation development and get rid of any worrisome build-ups of fuel. Careless human behaviour can also be a cause of these conflagrations.

FACING More than 5,000 international firefighters from a dozen countries were enlisted to help fight the flames in Canada. Here, South African firefighters sing and dance upon their arrival at the Edmonton International Airport. (David Bloom/Postmedia Edmonton)

While the causes of wildland fires can vary, climate conditions can also provide the setting that allows a spark to become a flame. And in 2023 across much of Canada, those conditions were a drought-fraught danger. Winter snowfall had been weak; the spring runoff was bleak. Rivers meandered instead of rushed. Rainfall was light, but the sun was bright. May temperatures skyrocketed to blistering highs more often seen in the middle of summer than in the early days of spring.

Canada's forests withered. Parched conditions left woodlands vulnerable to the slightest spark. In April, wildfires started popping up across the country. By May 4, things began to look alarming, starting with Alberta, where the prairies roll west to greet mountains and forest. An astounding 44 wildfires started that day, bringing the fire count to 72. Within 24 hours, that number rose to 92—and one-third of those fires were out of control.

Residents in hamlets, villages, towns, and First Nations communities got word: Leave! Fire was headed their way. Within the month, dozens of communities declared states of emergency or dealt with evacuation orders. More than 19,000 worried souls took to the highways, looking for safe refuge, as flames licked the edges of their vehicles.

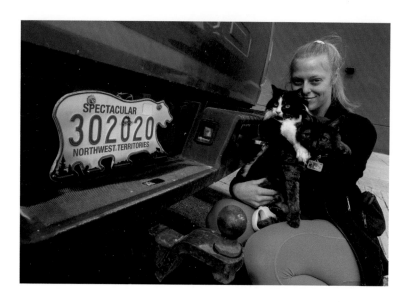

"It was a sight of doomsday," said one Alberta evacuee, Lyla Sleno.

Volatility continued for weeks, with the province reaching its most destructive season on record for wildfires—1.7 million hectares (4.2 million acres) scorched by almost 900 fires—with at least 2 months of the wildfire season still remaining.

Fires sparked in most other provinces and territories, too, including the Northwest Territories, Yukon, British Columbia, Saskatchewan, Manitoba, Quebec, Ontario, and New Brunswick. But it was Nova Scotia that grabbed the most headlines as May drew to a close. Two intense fires ripped through the province of lighthouses and lobster.

"All hell is breaking loose," Halifax Fire District chief Rob Hebb said at the time. The Barrington Lake fire in the southern portion of Nova Scotia grew to become the largest wildfire the province had ever seen—twice as big as anything else ever experienced there. A second major fire invaded the province's most populated area—the Halifax Regional Municipality—leading approximately 18,000 people to evacuate their homes. In the end, more than 300 homes and structures were lost to flames between the two fires.

AS MAY DREW TO A CLOSE, fire statistics were grim. The Canadian land scorched by wildfires had already reached the annual average—and the wildfire season was just beginning.

The world watched Canada's growing infernos. Firefighters from around the globe, ultimately from a dozen countries and numbering more than 5,000, began arriving to assist the frontline heroes trying to save the forests and, in many cases, their neighbours' homes and businesses.

The world paid attention for another reason, too. Wildfire smoke, which had choked much of Canada for the past month, began curling its acrid fingers around American states and even reaching out across the Atlantic Ocean to dim skies over Portugal, Spain, France, and the United Kingdom.

June brought more fires, in Ontario and particularly in Quebec. In an average year, "la belle province" would see only 247 hectares (610 acres) consumed by flames by June 5. But, this year, that number had exploded to a shocking 158,000 hectares (390,000 acres) by the same date—more than 600 times greater than usual. All that fire began emitting a health-hazardous haze that moved southward.

"Particularly noteworthy within the intensive protection zone [the area where normally all fires are fought] is that the timeframe between June 1 and June 20 witnessed more land consumed by fire than the cumulative sum of the preceding 20 years," said research scientist Yan Boulanger. "These fires have produced dense smoke plumes, triggering air quality alerts across densely populated areas of Canada . . . and the northern United States; and the consequences have even crossed the Atlantic, casting hazy skies over Western Europe."

In the United States, the smoke hung heavy, with many American cities setting records for their worst air quality ever.

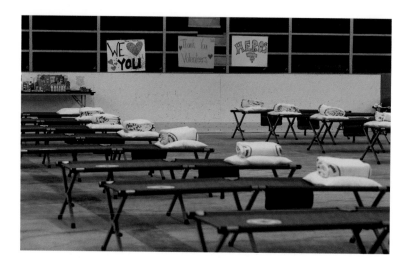

The smoke presented a health hazard everywhere from Minnesota and Indiana to the Mid-Atlantic, East Coast, and the South. Tabloid newspapers shouted their concern with headlines such as "Blame Canada."

An estimated 123 million Americans received health warnings about poor-quality air due to the Canadian smoke. Residents were cautioned to stay inside when possible or wear protective masks. Elderly people and those with frail health received warnings to avoid the smoke at all costs. The smoke led to hazy skies, sometimes cast in an other-worldly orange glow, while organizers cancelled everything from kids' camps to sporting and cultural events. When smoke migrated south again in July, an estimated 70 million people in 32 states were affected. The impacts of Canadian wildfires continued to spread.

Those impacts became deadly. A nine-year-old Canadian boy, who suffered from asthma his entire life, died after having an asthma attack. Medical examiners investigated the death as being caused by a condition aggravated by wildfire smoke.

On the front lines of fires, the toll on firefighters grew heavier, too, as four perished in July while doing the job they

loved. Devyn Gale, 19, died when a tree fell on her while she tackled a blaze near Revelstoke, B.C. Adam Yeadon, 25, was also fatally injured by a tree while fighting a fire near Fort Liard, Northwest Territories. Ryan Gould, 41, died when the firefighting helicopter he was piloting crashed in northern Alberta. Zak Muise, 25, lost his life when his ATV rolled over a steep drop while he fought a B.C. fire.

"This wildfire season has been profoundly awful," B.C. Premier David Eby said. "We are so grateful to . . . all of our firefighters for their daily heroism. This tragic news reminds us yet again of the extraordinary sacrifices they make to keep us safe."

AS THE SUMMER PROCEEDED, so did the number of fires roaring through Canadian forests. Some made the devastating jump into communities, such as Enterprise in the Northwest Territories. The tight-knit hamlet was once a vital service stop and gateway for those entering the North. Now it was a pile of smouldering rubble and ash after a heartbreaking wildfire incinerated 90 percent of all structures.

Meanwhile, another fire in the Northwest Territories danced dangerously close to the capital city of Yellowknife. Another evacuation order came down—this one on a mega scale—leaving the community akin to a ghost town. Thousands of residents fled the flames and went to Alberta and B.C. via commercial airlines, Canadian Armed Forces aircraft, and special evacuation flights. Hospitals, homeless shelters, seniors' residences, animal shelters, and jails emptied as part of a massive evacuation plan for 22,000 people.

Most Yellowknife residents, however, drove to safety on the solitary, two-lane highway that eventually heads south, out of town. The drive proved harrowing. Flames roared through hapless trees lining both sides of Highway 3. Fiery

embers streaked through the sky, landing on cars, trucks, and campers that snaked along the road in lines of traffic that stretched for miles. Heavy, black smoke turned day to night, obscuring vision, creating chaos, and causing evacuees to wonder if they would survive the fiery journey.

Numerous other NWT communities evacuated residents, too, leaving many people to share stories of trepidation and terror. Yvette Bruneau recalled how she grabbed two packed bags and her two-year-old dog, Speckles, as she left Hay River on August 13. The fire, however, was at its peak as she got on the road.

"I remember driving through there and I drove through flames," said Bruneau. A thick haze obscured almost all visibility, and it caused Bruneau to drive into a ditch. "I phoned my son and I said, 'Well, if I don't make it out, I love you.' He said, 'Mom, I love you, too.'" She then told him: "Do not come after me. You will not make it."

After that call, Bruneau climbed up a nearby hill with her dog and waved her arms frantically while yelling "Please help me! Please save me!" A passerby stopped to rescue her as well as another driver whose vehicle had also hit the ditch.

"I'm blessed that I'm alive," said Bruneau.

BRITISH COLUMBIA ALSO saw wildfires take a wicked turn in August. The province had already broken its record for most area burned during a wildfire season by the middle of July. More than 1.4 million hectares (3.5 million acres) were scorched, beating the 1.35 million hectares (3.3 million acres) that had burned during the entirety of the 2018 season.

A new ferocity in the flames left people gasping. With heat blasts and high winds whipping up embers, up to 500 active fires blazed across the province on some days. Most

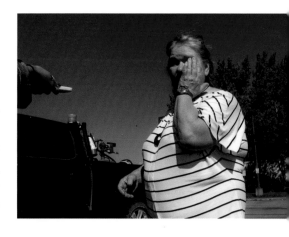

foreboding, perhaps, was the Donnie Creek fire. It became the largest fire to ever strike B.C., the culmination of eight smaller blazes joining together in an incendiary demonstration of their power. By mid-August, the Donnie Creek fire had devoured an area of land bigger than the entire province of Prince Edward Island.

A different wildfire, however, instilled the greatest fear. The McDougall Creek wildfire terrorized thousands in West Kelowna, ultimately razing about 189 homes and causing the evacuation of thousands. Firefighters said they'd never seen anything quite like those fast-moving flames.

"It was a devastating night last night, probably one of the toughest of my career—the toughest of all our firefighters' careers likely," West Kelowna fire chief Jason Brolund said after the first hours of fighting the blaze in the city. "It was one of the most challenging nights of firefighting in our history . . . We fought 100 years' worth of fires—all in one night."

And the nightmare wasn't over.

"We may have another scary night tonight," Brolund warned.

He was right. It took several long days before the fire—which could take months to completely extinguish—was chased out of the city.

Residents evacuated West Kelowna, many to the city of Kelowna on the opposite side of Okanagan Lake. From the shores, people watched flames march down the hillside and annihilate neighbourhoods in their hometown.

"We stood in [a] parking lot for 3 hours and we watched everything burn," one West Kelowna resident, Elizabeth Twyman, said through tears.

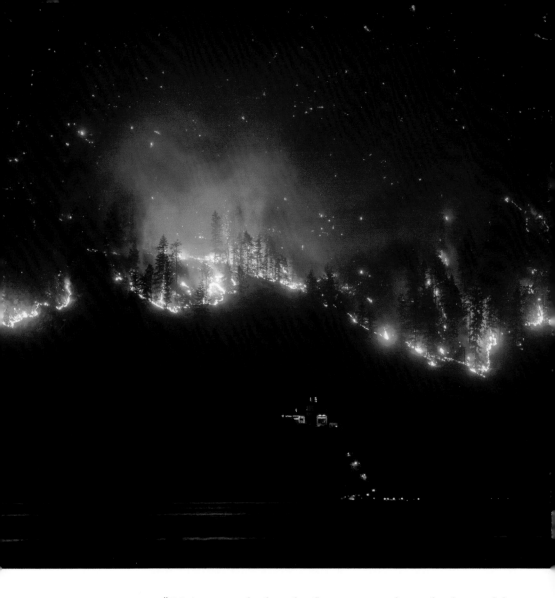

"We just watched as the flames came down farther and farther," added her next-door neighbour Tiffany Genge. Unable to believe their eyes, they borrowed a pair of binoculars from someone nearby.

"Elizabeth looked through them, put the binoculars down, looked at me and just started crying," recalled Genge. "She said, 'It's gone. It's all gone.'"

WILDFIRES UNFURLED MORE FURY in B.C. as August became filled with crisis after crisis. Fire began roaring through the Shuswap, a popular four-season destination dotted with idyllic communities, shady forests, and pristine waterways. The Bush Creek East wildfire viciously swept through the area, taking an estimated 168 structures, including many homes. Officials with the Columbia Shuswap Regional District called the blaze "devastating," noting it also knocked out hundreds of power poles and lines.

Many residents defied an evacuation order, staying to protect their property. When others tried to cross a roadblock into the evacuated area to take supplies to those residents who stayed behind, a confrontation occurred with RCMP.

Tempers flared along with the flames. The residents' actions attracted both criticism and support. Many understood their desire to try to save their homes, while others questioned if the residents' decision to stay would create additional problems if at some point they needed rescuing. The BC Wildfire Service also expressed concern that firefighting equipment—pumps, sprinklers, hoses, and ATVs—had been moved or stolen, because some residents believed they had a better idea of how that equipment should be utilized. The residents and fire personnel eventually began working together to battle the blaze.

The highly charged atmosphere proved no surprise. Dealing with wildfires frayed the nerves of many. Evacuees from B.C. and the Northwest Territories grew tired, wondering when they could return home. Understandably heated remarks from NWT Premier Caroline Cochrane reflected that emotion as she visited evacuees staying in Calgary. Cochrane said she'd been asking for better roads and communication technologies to enhance safety for NWT residents for years.

"I'm tired. I've been tired for a long time for asking for infrastructure," Cochrane said. "And now I'm angry."

The emotional impacts along with economic consequences of the wildfires still need to be calculated, but all involved expect a hefty price tag. B.C. declared a state of emergency and banned travel into the Kelowna area, as evacuees and emergency responders needed any and all available shelter. The tourism season was in shambles. With more than a month left in the wildfire season, the B.C. government announced it had already spent more than a half billion dollars in fire suppression.

By August 26, wildfires had chewed up and spit out almost 1.8 million hectares (4.4 million acres) of land in British Columbia, with 71 percent of the fires caused by lightning and 23 percent triggered by human activity.

Occasionally, bright bits of news would spark, providing welcome respite from weeks of soot and smoke. A B.C. firefighter originally from the Netherlands was scheduled to take his oath and become a Canadian citizen in August. He chose to stay on the ground fighting fires and participate in the ceremony via Zoom from the scene of a wildfire.

Another bright spot? Poomba the pig, who survived the fire that devastated her home at Broken Rail Ranch in West Kelowna. When a helicopter pilot saw the pig in the middle of ashes and rubble, he threw down a few granola bars so she could survive until rescuers reached her. Poomba became a "symbol of survival and hope," said Keramia Lawrie, whose parents owned the ranch.

For even greater signs of hope, one only had to glance at the children's artwork that graced the windows of firehalls and other community buildings throughout the Okanagan. Inspired by the heroic efforts of firefighters to save so many neighbourhoods, children took crayons and markers in hand to create cards and drawings of thanks.

With autumn approaching, many hoped the fire season would wind down, but experts warned that would likely not be the case. Drought conditions kept forests in prime condition for blazes. And the growing phenomenon of "zombie fires" (as some people call them) can keep embers hibernating in the ground during the winter for months, re-emerging in spring when vegetation again begins to grow.

WILDFIRES HAVE BEEN part of Canada's history since long before European settlers arrived. Indigenous peoples saw fire as a gift from the Creator. Occasionally, they would use low-intensity fires to rejuvenate the land or forest ecosystem. When Europeans arrived on North American shores, they brought with them a complicated attitude toward fire. They desired fire to provide warmth for shelters and heat for cooking, but they feared its ability to exist as an element they could not control.

Tales of wildfire woe abounded for those settlers. Archived newspaper pages reveal stories of wildfires that wiped out families and communities over the years. For example, the town of Lac La Biche—a 2.5-hour drive north of Edmonton—was consumed by flames in 1919. Residents fled into the nearby lake and swam out to safety, where they watched the blaze raze almost the entire town.

More recent fires equalled that level of destruction. A 2-hour drive west of Lac La Biche sits the 7,000-person

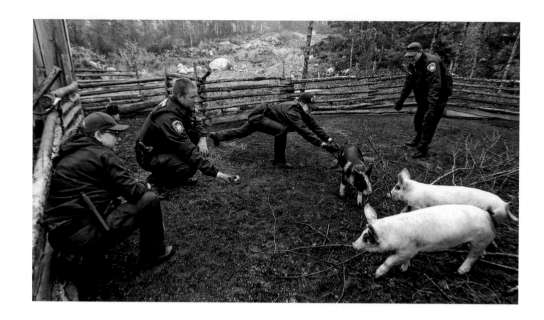

community of Slave Lake, tucked into the arms of a dense boreal forest. In 2011, a small bush fire, which officials believe was deliberately set, flared into an inferno that destroyed one-third of the town, including more than 500 homes and businesses, along with hundreds of vehicles and campers. With $750 million in damage, it became the second-largest insurable disaster in Canadian history at the time.

But just 5 years later, a blaze—that ultimately became known as "The Beast"—struck the city of Fort McMurray, a 4.5-hour drive away. The fire seemed possessed, behaving unexpectedly while creating its own wind currents and lightning. In the end, 88,000 people fled their homes, and 2,400 buildings, including 1,800 houses, burned to the ground. It took an estimated $9 billion to rebuild the city.

Fresh in the memories of many Canadians is yet another destructive fire: the 2021 conflagration that destroyed 90 percent of the village of Lytton, B.C. Two people perished in the fire, which resulted in $78 million of insurable losses. Just days earlier, the village had recorded the highest temperature

ever seen in Canada—49.6°C (121.3°F)—reflecting the changing climate the world faces.

Now another chapter in the history of Canadian wildfires has been written. The stories from May to August 2023 captured on the following pages merit a place in our shared history. Tens of thousands of people faced trauma as they fled their homes and oncoming flames. Hundreds lost their houses and all of their worldly possessions, suffering heartbreaking financial ruin. Even more gut-wrenching, the blazes led to the deaths of four firefighters, while thousands more risked limb and life to keep communities safe. And there's an as-yet untallied amount of damage to the economy, to many small businesses, to tourism and forestry industries, to the environment, and to ecosystems across the land.

So much of the forest where people live, play, and work is gone. The impacts of the 2023 wildfire season will reverberate for years to come.

ABOVE A French firefighter assists with wildfires at Lac Larouche in Quebec as smoke from Canada's worst-ever wildfires severely impacts air quality across Canada and much of the United States. (Photo by SOPFEU/Lieutenant Emma)

MAY

THE SPARK

S THE 2023 wildfire season started in Canada, clouds of concern appeared on the horizon. Clouds laden with hoped-for rainfall, however, didn't. One word described the spring weather across the country: *dry.*

A walk through the forest in many of Canada's provinces and territories revealed a problematic picture. Carpets of fallen pine needles crunched underfoot. Leaves of deciduous trees curled toward the sun. Spring runoff slowly trickled through streams and brooks. A drought cursed much of the country.

April showers had been sparse in the Maritimes, with most areas receiving only 20 to 50 percent of their usual precipitation for the month. In Ontario, the mercury rose to an unseasonably hot 30°C (86°F) in a mid-April heat wave, which oddly occurred about 8 days after an ice storm plagued the area. After that storm, Quebec and Ontario experienced abnormally dry springs. The same label was applied to much of the Prairies, with swaths of drought—ranging from moderate to severe—hitting various parts of Manitoba, Saskatchewan, and Alberta. Arid weather also afflicted many parts of British Columbia and Northern Canada.

Conditions were ripe for a wave of wildfires. Firefighters and forestry officials began preparing the best they could. Several provinces held news conferences, discussing the work

FACING Halifax Regional Fire and Emergency firefighter Zach Rafuse works to put out fires in the Tantallon area. More than 16,000 people needed to leave their homes in Nova Scotia due to May 2023 wildfires. (Photo courtesy Communications Nova Scotia)

21

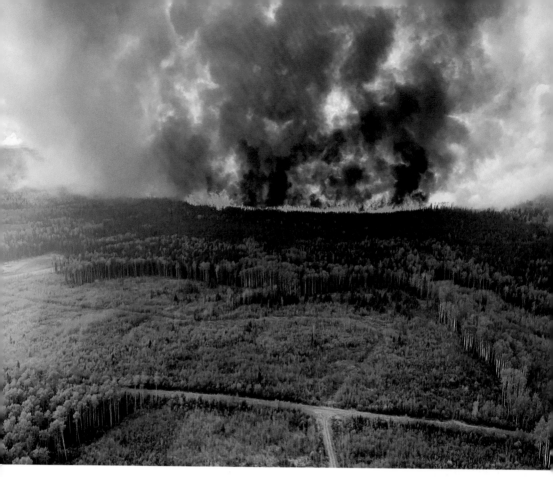

they did to prepare for the wildfire season. Wildland fire-fighters were trained; supported tankers would be available; and specialized equipment was ready to go. But would it be enough to protect parched forests and prairie land?

"As a result of drought conditions, the BC Wildfire Service is observing more advanced fire behaviour than what is typical at this time of year," Bruce Ralston, Minister of Forests, warned in April. Meanwhile, the Alberta government said, "While it is too early to predict what the 2023 wildfire season will look like, spring rainfall will have a significant impact on what can be expected."

That rain never fell.

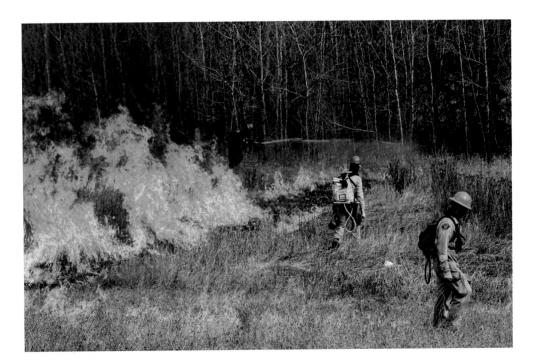

ABOVE Firefighters with the Fort McMurray Fire Department conduct a controlled burn near Highway 63 on April 27, 2023. The controlled burns are part of the FireSmart program, which is designed to fight and prevent fires in the region. (Vincent McDermott/*Fort McMurray Today*, Postmedia Network)

BY THE MIDDLE OF MAY, Canadians felt like it was the middle of summer. Heat waves rolled across the country. Precipitation was scarce.

"We've had extended periods of long, drying days, making us feel like we're in August or July," explained B.C. fire behaviour specialist Ben Boghean. "We had some of the hottest May days we've had on record. We haven't had the moisture, and that's over-layered on a very dry winter, which is compounded even more by the fact we had extreme drought in the fall." Late fall fires that scorched the earth well into October and November the previous year, along with lower-than-average snowfalls, exacerbated the conditions.

Flames began to flicker.

On May 4, the Alberta government put out its first wildfire update of the year—fires were spreading. Coincidentally, it was also International Firefighters' Day—a time when people

are encouraged to honour the sacrifices that firefighters make to keep communities safe. Few expected those sacrifices to be as heavy as they became in Canada in 2023.

"Every day, firefighters suit up and protect our homes, businesses, communities, and our forests," Mike Farnworth, B.C.'s Minister of Public Safety and Solicitor General, said at the time. "This work is dangerous. They put their own safety—and sometimes lives—on the line to protect the safety of countless others." No one knew how true those words would ring as the fire season began.

In Alberta, 44 new wildfires started that day alone, meaning 72 active fires were now consuming trees, fields, and anything else standing in the way. Within 24 hours, the number of active fires rose to 92, with one-third raging out of control.

The evacuations began.

More than 13,000 Albertans were ordered to leave their homes as flames approached and in some cases invaded towns and First Nations communities. The mandate to evacuees was simple: Gather family, valuable documents, medication, pets, and go.

The exponential growth of fires demonstrated how "extremely fluid" the wildfire situation was, said Stephen Lacroix, director of the Alberta Emergency Management Agency. "This is a stark reminder of just how unpredictable and powerful wildfire can be."

In Alberta, mandatory evacuation orders were in effect for Yellowhead County (including Evansburg, Wildwood, Lobstick, Hansonville, and Brazeau Dam), Edson, the county of Grande Prairie, Brazeau County (including the entire 7,200-person Drayton Valley), Sturgeon Lake Cree Nation, the Fourth Creek area of Saddle Hills County, Lac Ste. Anne County, Entwistle, Fox Lake/Little Red River Cree Nation,

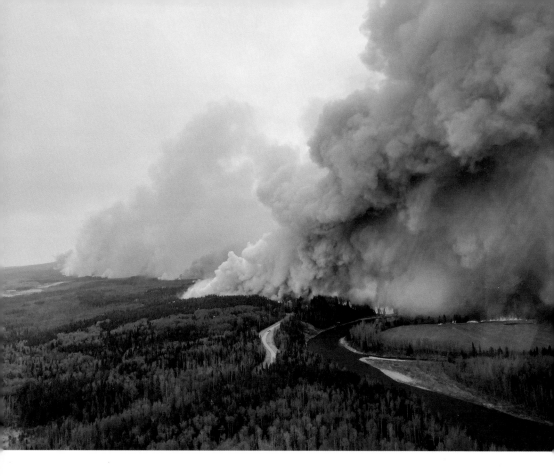

and Leduc County. More areas would follow, including Rainbow Lake, Little Smoky, East Prairie Metis Settlement, Fairview, and Greenview.

As fire marched into towns, the devastation grew. In Fox Lake, for example, flames razed buildings, including 20 homes, a store, a water treatment plant, and a police station. Roughly 55 firefighters, 5 helicopters, 6 structure-protection crews, and 8 pieces of heavy equipment fought those flames. A dramatic evacuation of more than 100 residents occurred via helicopter.

Traffic chaos ensued as highways faced closures due to smoke and visibility issues. A fire ban blanketed the entire province. No open fires were allowed. Off-highway vehicles were banned from public land and trails.

Some evacuees heard that they needed to leave their dogs, cats, birds, and other pets behind because it was unclear what pet facilities would be available when they reached remote evacuation centres. Time was of the essence, and the focus remained on evacuating people. Protecting human life remained the priority, leaving many pet owners in tears.

As one family of evacuees left the remote community of Fox Lake, their dogs followed, running down the driveway and then sitting and watching as their family drove away.

"I cried so much when they sat there looking at us leaving them," read the message from the Fox Lake family, posted online—a direct message between a Fox Lake resident and Robin Bellerose, who runs the New Beginnings Animal Rescue Society in neighbouring High Level.

Bellerose struggled for days to get the necessary help for the pets who were left behind. She counted about 100 animals who were left in homes, or left to run free, or tethered in yards during the rushed evacuation that began as the Paskwa wildfire bore down on the town.

Darreyl Sowan, an emergency management communications coordinator, said whenever an emergency occurs, human life tops the priority list for rescuers. However, whenever the firefighters saw pets, they stopped to feed them. While non-emergency personnel weren't allowed into the area—because it disrupts operations such as water bombing—Sowan said workers did the best they could to take care of the animals that remained behind. Photos posted to social media showed firefighters with enormous bags of kibble feeding dogs in a field in town. Residents identified their pets in the photos, thanking the firefighters for taking the time to feed them.

Fires continued to rage, and 7 communities in Alberta declared states of local emergency, with one band council resolution also put in place. That number would grow to 19 states of emergency within days, along with 2 band council resolutions that allow First Nations to provide instructions and clarity in emergency situations.

The impacts of the wildfires grew. In evacuated areas court dates were adjourned, medical appointments cancelled, dialysis therapy interrupted, and cancer treatments postponed. Patients needed to be evacuated from the Drayton Valley Hospital to hospitals in communities safe from the flames. Schools closed, too, eventually leading the province to exempt evacuated students from writing diploma exams.

Economic repercussions began occurring in a myriad of areas, including the energy industry. The wildfire southeast of Edson, for example, became one of the largest in the province, with 24,000 hectares (59,305 acres) aflame and causing nearby oil and gas facilities to close. Farmers, meanwhile, struggled with the havoc of losing livestock and crops to fires. Some tried to move herds to safe areas, and the Alberta Association of Agricultural Societies worked to help them, but agri-food losses mounted.

WITHIN A DAY and a half, the number of Albertans facing mandatory evacuation orders mushroomed. The increasing number of wildfires chased more than 24,000 people from their homes. Alberta Premier Danielle Smith said she had no choice on May 6 except to declare a state of provincial emergency due to the threat of wildfires.

"The safety and well-being of those affected remains our top priority," said Smith, noting the emergency status would

enable the province to access emergency funds more quickly and mobilize firefighting support faster. "This is not a step that we took lightly . . . but it's one that will allow the quickest and most effective response.

"Much of Alberta has been experiencing a hot, dry spring, and with so much kindling, all it takes is a few sparks to ignite some truly frightening wildfires," Smith said. "These conditions have resulted in the unprecedented situation our province is facing today."

Hot, windy weather made the wildfire situation worse. "It has been an extremely challenging day for firefighters here," Christie Tucker, information unit manager for Alberta Wildfire, said while discussing the dangerous situation on May 6. "We were battling very strong winds, hot weather, and those winds produced extreme wildfire activity."

Now, thousands of people needed a place to rest their heads that night. The largest influx of evacuees was coming from Drayton Valley, with 7,200 souls fleeing mostly to Edmonton and a few even going as far away as Calgary, 300 kilometres (186 miles) south. Most left their communities with little more than the clothes on their back.

"I don't know that I ever recall seeing multiple communities evacuated all at once in fire season," said Smith.

Evacuees, of course, worried. They worried about the fires. Worried if their homes and businesses would survive. And worried about looters taking advantage of empty towns.

Trying to allay fears, the RCMP held a news conference, noting they'd arrested four people breaking into a gas station in Drayton Valley and adding they were watching for looters. Police also reminded residents that evacuation orders weren't optional.

"Anyone who chooses to ignore evacuation notices is putting not only themselves in danger, but also potentially putting others, including first responders, into harm's way," said deputy commissioner Curtis Zablocki.

Evacuees, facing exhaustion, wondered when they'd be able to go home. They rested on cots in evacuation centres, while volunteers tried to keep seniors comfortable, children entertained, and pets calm. Many of the evacuees from Drayton Valley had just settled into their beds for the night on May 11 when their evacuation order was issued.

Lyla Sleno bundled up her 7-year-old son, 97-year-old grandmother, 3 dogs, and cat before leaving her Drayton Valley home for Edmonton. She grabbed one special keepsake on the way out the door.

"I have a little box that has everything from when he [my son] was born, and I took it," Sleno said. "You have to realize that as long as your loved ones are out, then everything else is immaterial and can be replaced," she said, adding her son's birthday party, which had been only 2 days away, now wouldn't occur.

Fleeing the wildfire threatening her home, Sleno was struck by the ensuing chaos as others struggled to do the same.

"People were racing around, every gas station was covered with people getting fuel," said Sleno. "If we were waiting to exit town at a set of lights . . . they were weaving in between us to try to get to where they were going."

FACING Christie Tucker, information unit manager for Alberta Wildfire, and Colin Blair, executive director of Alberta Emergency Management Agency, provide an update as early season wildfires created a severe situation in Alberta in May 2023. (Greg Southam/ Postmedia Edmonton)

Compounding the disorder was the smoke engulfing the town, making it difficult to see approaching vehicles, Sleno said as she stood outside the Edmonton Expo Centre, then serving as an evacuation site for many Drayton Valley residents.

Nearly 700 of those evacuees and their pets registered for help at the centre on the first day, with many more expected in the coming hours. Some arrived on shuttle buses, while others drove themselves, navigating traffic snarls and flame-lined roads. The centre did its best to provide for basic needs, such as food and clothing, along with offering places to rest, play areas for children, hygiene supplies, mental health support, and a kennel for pets.

"My heart goes out to people," said Gerry Clarke, Edmonton Emergency Response Team coordinator. "If they come down here, they can get the assistance they require, they can get professional help. We're providing support for people for whatever they don't have. They're displaced. They don't have lodging, they don't have food ... A lot of these people have run

out with the clothes on their backs. Anything people need on a day-to-day basis, we have to try to . . . locate that all here."

The hope, Clarke said, was to provide these people in crisis with a sense of normalcy.

"We have to think of the things you and I do on a daily basis to relax and get our mind off things," Clarke said. "If you can get them away from that situation and allow them to focus on something else, give that sense of control back, it goes a long way with mental health."

Financial hardship often accompanies evacuations. Evacuees aren't able to work, their places of employment are closed, and money can become scarce very quickly. To assist, in May the Alberta government announced that any Albertan who was under a mandatory evacuation order for 7 or more consecutive days would receive financial help in the form of a payment of $1,250 per adult and $500 for each child under 18. Offers of help poured in from other Canadians, as well. The Canadian Red Cross established the 2023 Alberta Fires Appeal, with funds being used to support those impacted by wildfires. The governments of Alberta and Canada said they would match every dollar donated.

"We're going to do whatever it takes to make sure that they [evacuees] have the resources that they need, and we're going to do whatever it takes to make sure that these fires get fought so that they can return home," said Mike Ellis, Alberta's Minister of Public Safety and Emergency Services.

"The situation once again truly goes to show the Alberta spirit," Ellis said of the many volunteers assisting evacuees. "In times of need, we really rally together and we take care of each other."

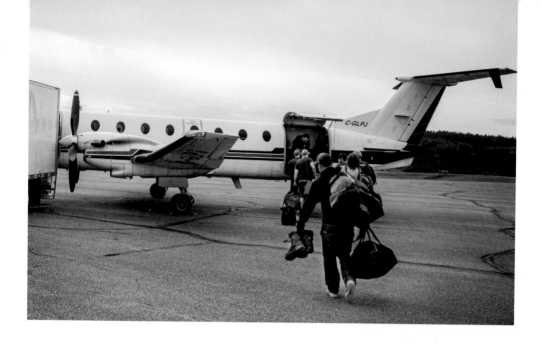

THE TIRELESS WORK of firefighters on the frontlines inspired awe. Their physical and mental endurance seemed super-human, but it proved impossible to keep up with the super-speed of the wildfires. Other provinces began sending firefighters to help battle the Alberta blazes. By May 7, more than 80 firefighters arrived from Ontario, New Brunswick, and Quebec. British Columbia also sent personnel and equipment, despite the fact the number of active wildfires in that province had crept up to 62. Alberta now had 700 wildland firefighters, pieces of heavy equipment, and airtankers responding to the wildfires.

Within a few days, the army arrived. Troops from Third Battalion, Princess Patricia's Canadian Light Infantry (3PPCLI), and 1 Combat Engineer Regiment (ICER) began establishing operational bases in Alberta, while army reserve soldiers from across the province were deployed. Royal Canadian Air Force fixed-wing aircraft and helicopters moved people and equipment into position. Soldiers began helping with basic firefighting duties, mop-up operations, and evacuation of isolated communities.

Crews made progress battling the fire threatening Brazeau County, southwest of Edmonton, which included the town of Drayton Valley. More than 200 people worked on that fire line, the county said, adding that heat scans proved useful in identifying hot spots needing to be doused.

Resident Adam Norris said he knew many neighbours and other community members eagerly awaited the all-clear signal to return to their homes. But it just wasn't safe.

"There's some incredibly scary places that are still lighting up here," he said.

The fires kept growing, so the Canadian Interagency Forest Fire Centre called in more help. By May 14, American assistance began: 200 firefighters from Oregon, Montana, Idaho, Washington, South Dakota, and Colorado arrived. Within days, the tally grew to more than 800, as additional flame fighters reported for duty in Alberta from British Columbia, Quebec, Ontario, the Yukon, New Brunswick, Nova Scotia, Alaska, Washington, and Parks Canada. More soldiers reached Alberta, too. Canadian Armed Forces assisted by providing 200 members along with airlift resources for mobility, evacuation, and logistical tasks plus engineering support, including heavy equipment resources. In the coming days, an additional 100 soldiers would be deployed. Additional firefighters would also soon arrive from around the world, including Australia, New Zealand, South Africa, Chile, Mexico, and Costa Rica.

"The conditions are ripe for a wildfire to start and spread very quickly," Christie Tucker, information unit manager with Alberta Wildfire, said while explaining why the help was crucial. "It's going to get hotter. It's going to get windier, and we're expecting some extreme wildfire behaviour. We still don't have green grass and leaves all over the province, which means that the ground is very dry."

The battle could only be described as fierce. By the end of May, more than 2,900 wildland firefighters, 165 helicopters, 25 fixed-wing aircraft, and myriad pieces of heavy equipment fought to stop the conflagrations. Dozens of communities teetered on the edge of destruction. Evacuation orders in Alberta totalled 15 at various points in the month, while emergency alerts stood at 17. More than 19,000 Albertans encountered evacuation orders. The provincial government dispensed more than $29 million in emergency financial assistance to evacuees needing help.

Albertans across the province curtailed a multitude of activities as the fire situation worsened. The May long weekend brought a special request from the Alberta government: "Albertans are asked to restrict recreation activities on public land in northwest Alberta due to wildfire risk . . . Outdoor recreation, including activities like backcountry camping, mountain biking, and hiking, in these areas is not recommended. Some sites have been directly affected by wildfire, while others are at risk due to their proximity to active wildfires and forecasted conditions."

Additionally, the province closed more than a dozen parks, recreation areas, and campgrounds in areas where the fire danger remained high. Fire bans occurred in about 280 provincial parks and recreation areas, while government agencies issued special air quality statements as smoke began spreading.

"What we saw this year was certainly the kind of season that isn't reflected anywhere in our records," said Tucker. "It was an extraordinary year for us and for many of our neighbours across the country."

As May drew to a close, the month ended much as it began in Alberta—with flames threatening yet another

Alberta community. This one sat in northern Alberta: Fort Chipewyan. A strange silence settled over the hamlet as evacuation occurred and firefighters readied for battle.

Evacuating the community took great coordination. In the winter, frozen waterways allow for an ice road to be constructed to access Fort Chipewyan, but in the summer no road exists for entering or exiting the hamlet. Thus, when an evacuation order landed, options were to leave by air or by water. More than 800 residents departed the hamlet—many with pets in hand—on private air carriers. An Armed Forces Hercules aircraft also swooped in to pick up people. Others left on boats, headed for Fort McKay on a trip that could take up to 6 hours.

Chief Allan Adam of the Athabasca Chipewyan First Nation took to social media to ensure residents had the information they needed. From the airport, he reminded those who decided to stay behind to fight the fire that they must work with either the local fire department or Alberta Wildfire personnel. In such a remote community, many residents already possessed some firefighting training or background. Exceptional circumstances called for exceptional efforts.

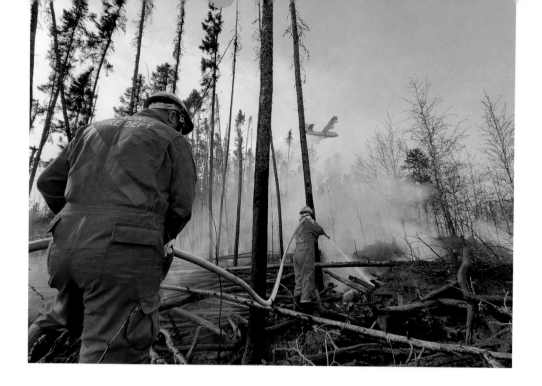

WILDFIRE WORRIES ALSO deepened in other parts of Canada throughout May. In the Northwest Territories, blazes led to the May 14 evacuations of more than 3,500 people in the town of Hay River and K'atl'odeeche First Nation. Problems started sooner than expected, Premier Caroline Cochrane said, adding: "Not unlike other jurisdictions in Canada, the Northwest Territories has seen an unprecedented early start to our wildfire season, forcing us to mobilize crews and equipment faster and earlier than ever." The NWT government offered a one-time $750 payment to people who lost employment income due to extended evacuation periods, while also matching donations made to the United Way NWT. (The federal government made the same matching promise.)

Evacuees, understandably, grew concerned as they waited for the signal that it was safe to return home. A re-entry plan occurred about a week and a half after the evacuation orders were issued.

"We know that everyone wants to come home," Hay River Mayor Kandis Jameson said. "We know that this has been extremely stressful on so many levels, and we are doing everything we can to get you back home as soon as it is safe . . . We had a safe evacuation, and we are not going to risk bringing people back too soon." Unfortunately, the people of Hay River would discover 11 weeks later that the flames would return with a renewed ferocity.

Meanwhile, in Saskatchewan residents saw more than double the number of wildfires usually experienced in the first half of May: 160. A provincial fire ban was mandated for Crown lands, provincial parks, and the Northern Saskatchewan Administration District. The Provincial Emergency Operations Centre was activated in response to wildfires moving through northern Saskatchewan. More than 1,000 residents were evacuated.

One evacuee spoke to reporters outside the Regina hotel where she sought shelter, saying the evacuation was one of the most terrifying experiences she'd ever had.

"You could just see flames in the air, like a block away behind my house," said Molly Herman. "I was literally shedding tears while I was packing my babies . . . The smell was exhaustively strong. I'm just praying dearly, God, that our homes are saved and that everybody's safe."

Fires led to power outages in some communities, leaving people without electricity for up to 3 days and leading to notable food spoilage in a dozen communities.

Throughout the month, more evacuation orders arose, at Buffalo Narrows, the Buffalo River Dene Nation, the English River First Nation, the Lac La Ronge Indian Band, the Canoe Lake First Nation, Deschambault Lake, and Île-à-la-Crosse.

FACING Firefighters from La Ronge Regional Fire Department battle blazes in northern Saskatchewan in May 2023. (Photo courtesy La Ronge Regional Fire Department)

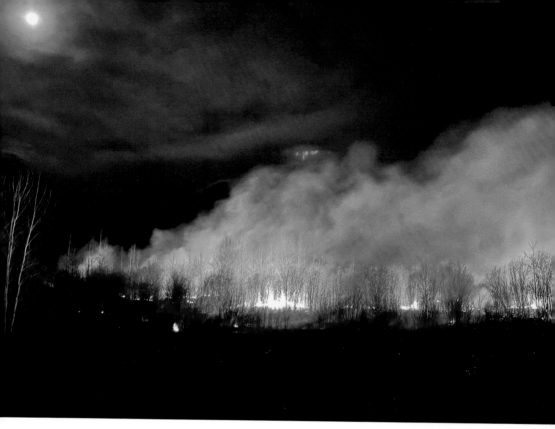

Fire destroyed more than 30 cabins in Buffalo Narrows. The loss devastated owners, as the buildings held rich family and trapline history.

By May 24, the total number of fires in Saskatchewan sat at 183. The 5-year average for this time of year was 106. A hot, dry spring after years of drought made for especially dangerous fire conditions, said the Saskatchewan Public Safety Agency (SPSA).

Every day the agency assessed where to deploy its resources, said SPSA president and fire commissioner Marlo Pritchard. "There is no 'let it burn' policy. The SPSA assesses every wildfire and makes a decision about the best way to manage each one. Our priorities include first and foremost human life, then communities, major public infrastructure, commercial forest, and other values.

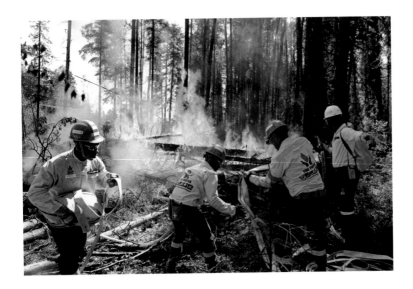

"The magnitude of a response does not necessarily equate to a wildfire's distance from a community—and, of note, healthy, vibrant forests are naturally renewed by fires, so it makes ecological sense to allow some non-threatening fires to occur unhindered," he added.

Steve Roberts, vice-president of operations for the SPSA, said fire crews faced additional difficulties in protecting property in 2023 because of the challenging fire conditions.

"These fires are extremely aggressive because of the spring conditions," Roberts said. "And because of the large volume of smoke they have been generating, that has greatly curtailed some of our activity both to get into these fires and get crews on the ground, but also to assess where we might have risks and threats."

Meanwhile in Manitoba, the government implemented fire and travel restrictions due to "high fire danger" in the southeast portion of the province, which also saw a 7,000-person evacuation from the Pimicikamak Cree Nation. Overall, however, fire risks didn't yet rank above average in both Manitoba and Newfoundland.

Fires in New Brunswick, on the other hand, consumed twice as much land as they did during the entire previous season. Prince Edward Island banned all campfires, bonfires, and backyard pit fires, concerned about the wildfire fuel left behind after the remnants of hurricane Fiona hit the province, downing trees and leaving dehydrated debris in its wake. Quebec's forest fire prevention agency moved to a high-alert status, with the danger of wildfires being called extreme, while Ontario also began implementing fire bans as dry conditions worsened.

In B.C., the number of fires sat at 311, compared to the 10-year average of 230, with 344,757 hectares (851,913 acres) consumed by flames, compared to the average of 18,420 hectares (45,516 acres). In a sign of what was to come, evacuation orders due to wildfires began popping up in B.C., in communities including Tzenzaicut Lake, about 600 kilometres (373 miles) north of Vancouver. More communities, such as Anahim Lake and the Ulkatcho First Nation, received alerts for possible evacuation.

As wildfires raged, an advisory board highlighted the need for the B.C. government to spend significantly more money to improve climate resiliency.

"Investment in climate resilience is more cost-effective than disaster relief," the 18-member Climate Solutions Council told the B.C. government. The council provided strategic advice on climate action and clean economic growth. Its members included academics from the University of B.C. and Simon Fraser University, business representatives (including from Shell Canada and Teck Resources), and representatives from unions, First Nations, and environmental and climate groups.

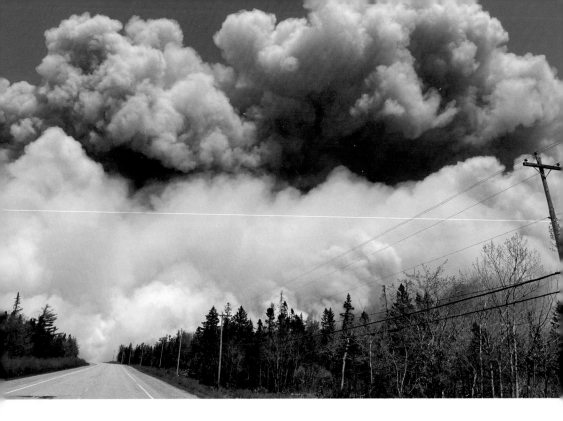

Both the Ministry of Environment and the Ministry of Emergency Management and Climate Readiness had begun developing a provincial hazard risk vulnerability assessment, cross-sector climate adaptation targets, and a climate-risk reduction plan, said environment ministry spokesman David Karn.

Colleen Giroux-Schmidt, one of the council's co-chairs and vice-president of corporate relations for Innergex Renewable Energy, said that as a volunteer board, they did not specifically calculate how much more money would be needed to build climate resiliency, but she stressed it was significant and would be much more than what was currently being spent.

Specific targets would be needed to create government accountability and also to set priorities that go beyond the 4-year election cycle, said Giroux-Schmidt.

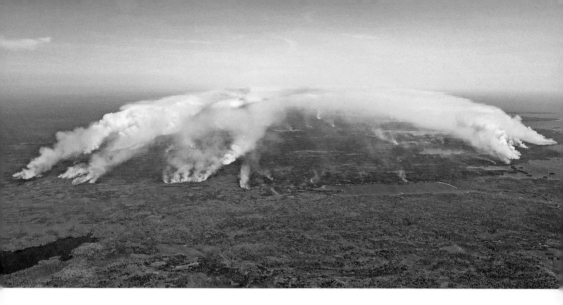

"It's the same in any organization. You have to drive results by having goals and targets. And if not, then there's no accountability back to the decision-makers to make sure that something has been prioritized," she said.

Dealing with climate and wildfires seemingly became more of a priority each week in 2023. By the end of May, wildfire activity had increased almost everywhere across Canada, with 1,802 fires having burned. By the end of the month, wildfires had scorched more than 2 million hectares (4.9 million acres) of Canadian land — almost reaching the per season average of 2.5 million hectares (6.2 million acres). And the most active months of the season were yet to come.

THE LAST WEEKEND in May proved to be even more destructive, as wildfire flames tore through parts of Nova Scotia. It was akin to all hell breaking loose, Halifax Fire district chief Rob Hebb said at the time. Two major fires caused thousands to flee their homes.

Flames shot skyward 90 to 100 metres (295 to 325 feet) during a major fire that erupted near Barrington Lake at the southern tip of the province, forcing the evacuation of more than 6,000 people. The fire destroyed more than 60 homes

and razed 250 square kilometres (96 square miles) of land. The Barrington Lake fire in Shelburne County ultimately became the largest fire in Nova Scotia's history—more than twice the size of any previous wildfire in the province.

But a second major wildfire threatened an even larger populated area: Halifax, a city of 480,000. Thick grey smoke choked the city as an out-of-control fire ravaged the suburban community of Tantallon in the Halifax Regional Municipality. About 14,000 residents were evacuated from the Westwood Hills subdivision and the Yankeetown/Highland Park subdivision of Hammonds Plains, just 30 minutes northwest of downtown Halifax. Throughout the night, more evacuation orders were mandated for Haliburton Hills, Glen Arbour, Pockwood Road, Lucasville Road, and the White Hills subdivision, Maplewood, McCabe Lake, and Indigo Shores.

Nova Scotia's Premier Tim Houston said at a news conference that his government would receive assistance, including several water bombers, from other provinces, and he'd contacted officials in the northeastern United States to seek additional resources.

"We are in a crisis in the province. And we want, and we need, and we will take all the support we can get," Houston said. "Unprecedented resources are being used because these fires are unprecedented."

He also expressed frustration at careless human behaviour contributing to the problem. "For God's sake, stop burning. Stop flicking cigarette butts out of the car window. Just stop it. Our resources are stretched incredibly thin right now fighting existing fires."

Many people faced devastating losses in the Nova Scotia wildfires. Katherine Tarateski was one of them. She, her

FACING This aerial photo shows the magnitude of the fire in Nova Scotia's Shelburne County in May 2023. (Photo courtesy Communications Nova Scotia)

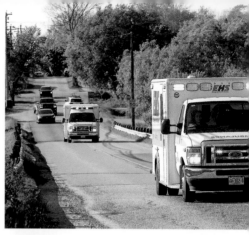

husband Nick, and daughter Mia were at a family gathering when they heard a wildfire was approaching their house. They tried to rush home to collect their dog and cat, but the neighbourhood was already deemed too dangerous to enter and police had blocked the street.

"The RCMP called me . . . to say they went to see our house, and it was burned down and they couldn't find the pets there," she told the Canadian Press. "The house can be rebuilt. But my pets . . . I'm just devastated. It's hard."

The quick-moving fire jumped roads as wind gusts as fast as 40 kilometres per hour (25 miles per hour) swirled sparks through the air. Waves of flames rolled across treetops. Residents posted videos of the fiery danger they faced, with flames

reaching out toward vehicles as people escaped the area. For some, one phrase came to mind: *the end of the world.*

The Tantallon blaze became increasingly worrisome as its fingers embraced Halifax-area homes, destroying at least 200 houses or structures and chasing 18,000 people from their houses.

"We are still dealing with a very dangerous and volatile situation," David Steeves, a spokesperson with the Department of Natural Resources told media, noting daytime temperatures reaching toward 30°C (86°F) worsened the situation.

The city of Halifax declared a state of emergency. Schools shut, power outages occurred, and phone and internet services were disrupted.

"We've got more fires than we have resources to support them," Scott Tingley, manager of forest protection at Nova Scotia's Department of Natural Resources, said during a news conference.

Videos on social media showed people driving through heavy smoke and past a string of wildfires. One dramatic scene depicted the view from the road as people passed a wildfire at ground level, through smoke so thick it blocked the sunlight, with sparks blowing across the road and flames reaching the tops of the trees. A BBC headline described the scene—in which a driver nearly rear-ends another vehicle that is barely visible in front—as "apocalyptic."

Another drive-by video from evacuees in Tantallon showed a towering column of flame and smoke burning in the backyards of large suburban family homes, with one property seeming to have just exploded, as if from a propane tank or vehicle fuel. Yet another brief video, posted by a Halifax lifestyle news site, showed a residential pool with the surrounding forest fully consumed by flames licking over the deck.

TOP RIGHT When a community faces an evacuation order, a complex plan is needed to help those who are sick or in care homes. Here, ambulances were dispatched to the Roseway Hospital in Shelburne County, Nova Scotia, to evacuate patients when a major fire moved close to the facility in late May 2023.

BOTTOM LEFT Halifax Regional Fire and Emergency Station 54 captain Natasha Prest directs efforts of firefighters in the Tantallon area on May 30, 2023.

BOTTOM RIGHT Department of Natural Resources and Renewables staff member Mark Shaw works to put out fires in the Tantallon area of Nova Scotia on May 30, 2023.

(Photos courtesy Communications Nova Scotia)

(The video appeared to be taken by someone who was in danger from the fire, barely a few metres away.)

Nathan Coleman, a Weather Network journalist, described speaking to a woman who ran through bushes to save dogs at a kennel. She'd reportedly been told by authorities, "If they're humans, we have buses to go get them. If they're dogs, it is what it is."

As of Monday morning, the evacuation zone stretched almost from St. Margaret's Bay in the west to Middle Sackville in the northeast, including the subdivisions of Upper Tantallon and Hammonds Plains.

In what was likely the largest fire response operation since the Halifax Regional Municipality was amalgamated in 1996, 170 firefighters and 54 vehicles worked through the night. Two airtankers flew in from Newfoundland, as well as other ground crews from around Nova Scotia. The power utility shut down large sections of the grid to facilitate the fire crews' response, disconnecting thousands.

Mike Savage, mayor of Halifax Regional Municipality, declared a state of emergency, which enabled closer coordination with other governments. Prime Minister Justin Trudeau expressed concern on one of his social media accounts: "The wildfire situation in Nova Scotia is incredibly serious—and we stand ready to provide any federal support and assistance needed. We're keeping everyone affected in our thoughts, and we're thanking those who are working hard to keep people safe."

The fires took a toll on firefighters, which at first numbered about 200 as helicopters and water bombers flew overhead. Volunteer firefighter Brett Tetanish fought back tears as he described arriving at a house fire in the Westwood subdivision, the scene where the first fires were reported.

"There were fires on both sides of the road, structures on fire. There were cars abandoned and burnt in the middle of the road," he told the Canadian Press.

At about 10 p.m., Tetanish spotted a home where flames were licking at a back wall. He and his team of volunteers extinguished the fire, then tore out parts of walls and ceilings to make sure the fire had not spread.

"It was a good feeling," he said, his face streaked with soot, dirt, and sweat. "We were able to save somebody's house after seeing so much destruction. It's kind of an emotional rollercoaster."

Tetanish, a fire captain who has a full-time job as an electrician, said the wildfire was the worst he's seen in 32 years of firefighting. "My body is sore. My joints are sore. My back is sore, and I think the rest of my crew feels much the same."

The raging fires that plagued Nova Scotia in May are not typically associated with provinces along the Atlantic coast, which are known for more moderate temperatures and high precipitation, John Clague, a professor of geosciences at Simon Fraser University in Burnaby, B.C., also said to the Canadian Press.

The Halifax fire is "a black swan event"—something unexpected but with a significant impact, Clague said. "People didn't actually anticipate that something like this could happen . . . And they probably weren't fully ready for it."

Clague added that if such a fierce fire can happen in Halifax, any other city in the country is vulnerable.

"I'm surprised, to be perfectly honest," he added. "I'm really surprised that this dry, warm weather has affected Nova Scotia to the point that something like this could happen. And to be perfectly honest, it frightens me."

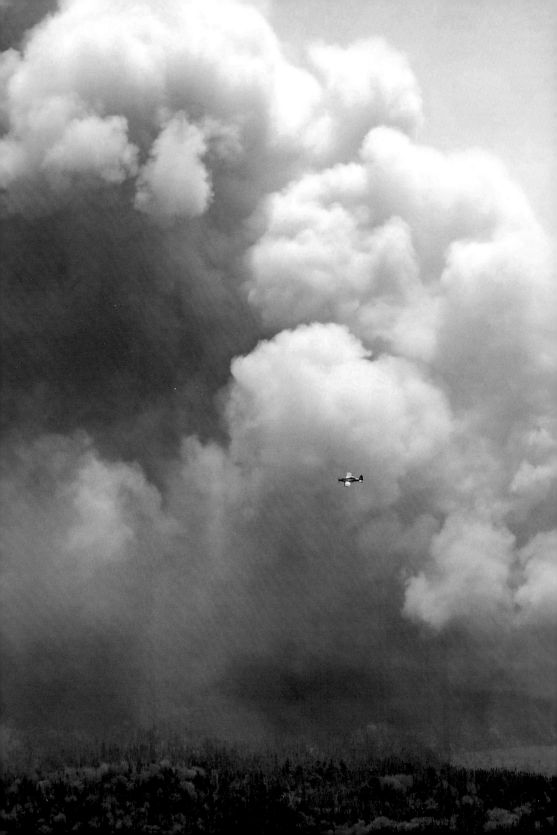

JUNE

THE SMOKE

WHERE THERE'S FIRE, there's smoke. So when Canada's record-setting wildfire season began dispatching hazy grey clouds across the country, it surprised no one. People were astonished, however, at just how far that thick, choking blanket of smoke travelled across North American skies.

In June, an intense batch of wildfires flared up in Quebec, exacerbating the atmospheric mess that afflicted much of Canada the previous month. Pungent plumes of smoke curled down along the eastern half of the United States. And it didn't stop there. In a transcontinental twist, Canadian wildfire smoke then drifted across the Atlantic Ocean, leaving European countries such as France, Spain, and Portugal in a haze.

The smoke irritated people's nostrils, scratched throats, and aggravated eyes. American authorities sounded the alarm over health hazards. The old, the young, the sick, and the weak should stay inside, they warned. By June 6, officials issued a "code red" air quality alert in many of the two dozen states affected by smoke—some of the most densely populated areas of the United States. Ultimately, 123 million people encountered air admonitions.

Meanwhile, the smoke created chaos everywhere it travelled. The haze disrupted flight schedules, impaired visibility,

FACING Giant plumes of smoke dwarf a plane, one of eight aircraft from neighbouring New Brunswick that were used to dump water and fire retardant on the huge Barrington Lake wildfire in Nova Scotia. (Photo courtesy Communications Nova Scotia)

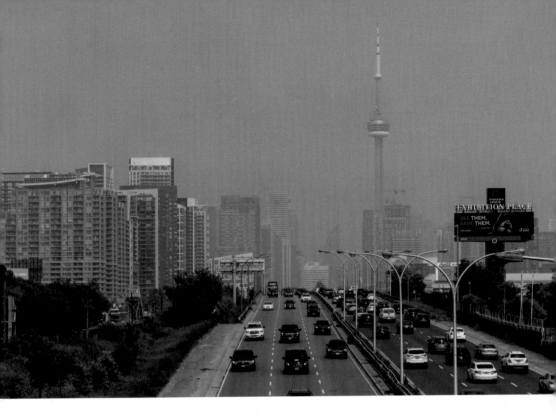

slowed traffic, and led to a myriad of cancellations. Schools in Washington, D.C., and New York City put a halt to outdoor activities. Philadelphia officials decided students should stay at home, as they switched classes over to online learning. The Washington Nationals cancelled a baseball game, and New York theatres cancelled shows—some on Broadway—including *Hamilton* and *Camelot*. People dug out and put on those COVID-era facemasks that had once been mandatory.

Thanks to Canadian wildfire smoke, New York City now had the worst air quality out of any big city in the world, even outpacing smog-strangled hotspots such as Delhi, India. Other American cities, including Cleveland, Buffalo, and Philadelphia, registered air quality ratings many times worse than usual.

"We recommend all New Yorkers limit outdoor activity to the greatest extent possible," cautioned the city's mayor, Eric Adams. "Those with pre-existing respiratory problems, like

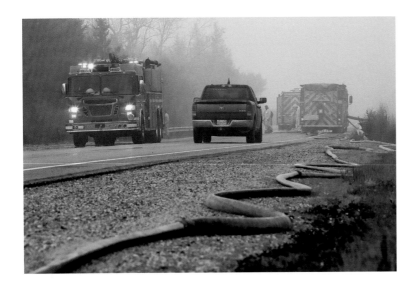

ABOVE Smoke-filled skies are an everyday occupational hazard for wildland firefighters, as this June 2, 2023, scene in Nova Scotia shows. (Photo courtesy Communications Nova Scotia)

heart or breathing problems, as well as children and older adults, may be especially sensitive and should stay indoors at this time."

The smoke remained and, within two days, New York City adjusted its warning upward to the infrequent "code purple," meaning the health risks of poor air quality increased for everyone. Philadelphia did so, too, as it became the city with the worst air quality in the world after New York's atmosphere improved slightly.

A kaleidoscope of colours filled these cities' skies, as tiny particles in the smoke obstructed wavelengths of light. Ethereal shades of red, orange, yellow, grey, muddy brown, and even lavender appeared, depending on the time of day. Thousands turned their eyes and smartphones upward, capturing peculiar pictures and sharing images on social sites. A blood-orange sun set over the Empire State building. The Washington Monument stood grey against a peach horizon. The Statue of Liberty almost disappeared into a yellow-brown haze.

In some places, people could even smell the smoke. Occasionally, a bit of ash would fall—a residual reminder to

Americans that their northern neighbours were living in a land of fire.

As the smoke caused day to look like dusk, some people in the eastern United States called 911 to ask what was happening. Others turned to the internet, sharing wacky theories about the smoke being caused by everything from a UFO invasion to a quest for world domination by mask mandate proponents. It harkened back to the Chinchaga River fire of 1950, also known as the "Great Smoke Pall." That forest fire seven decades ago in Alberta and British Columbia sent smoke over the ocean to Great Britain, while also blanketing much of the United States. During that smoke event, baseball stadiums used night-time lights during afternoon games. Streetlights came on during the day in Florida. Radio stations fielded calls from listeners, speculating the smoke was due to everything from an apocalypse or atomic explosion to an eclipse or alien infiltration.

While theories about the 2023 great Canadian smoke invasion may have been colourful, people were right to be concerned. The human body possesses defences that stop large airborne particles from entering the lungs—the nose provides a good filter—but the fine particles in wildfire smoke can slip right in. A fine particulate matter, known as $PM_{2.5}$, can get into the lungs, resulting in irritation and inflammation. Additionally, wildfire smoke can be comprised of more than the particles of burned trees and vegetation. If a wildfire has also destroyed homes, household contents, vehicles, and other manufactured items, a combination of toxic chemicals infuses the smoke, creating even more potential health hazards.

The lungs can clear out most particulates, but if a person inhales too many over too long a period, these organs become overwhelmed and susceptible to infection. It explains why

researchers have found that cold and flu cases increase in populations that experience a wildfire.

Health Canada also reminded people that wildfire smoke can cause headaches, coughs, sore eyes, sore throats, and sinus irritation. Unknowingly foreshadowing the July death of an asthmatic boy in B.C., the government noted smoke can also lead to other more serious problems, including chest pains, shortness of breath, wheezing, asthma attacks, and heart palpitations, while even entering the bloodstream.

"Less commonly, exposure to wildfire smoke can lead to stroke, heart attack, [and] premature death," Health Canada said. Other impacts could include an increased risk of dementia, Alzheimer's, and Parkinson's disease, research studies indicate.

Toxicologist Christopher Migliaccio, from the University of Montana, studied residents in that state who lived with hazardous levels of $PM_{2.5}$ for 49 days due to wildfire smoke in 2017. His team found study participants suffered from a decrease in lung function one year later.

ABOVE The smoke caused countless people to pull out their pandemic-era masks and start wearing them again, in an attempt to filter out particles floating across North America from the wildfire haze. (Julie Oliver/*National Post*)

Emerging evidence indicates wildfire smoke may also cause low birth weight and adversely impact a developing fetus, said Jiayun Angela Yao, a senior scientist in climate preparedness and adaptation at the B.C. Centre for Disease Control. Additionally, a 2022 study from Montreal's McGill University found higher rates of lung cancer and brain tumours in people exposed to wildfires in Canada.

"We are seeing higher levels of air pollution in communities with the wildfire smoke, and we just don't know what the long-term effects are yet. And so, we're really encouraging folks to think hard and try to avoid it if at all possible," said Dr. Emily Brigham, an assistant professor of medicine at the University of B.C.

WITH SMOKE AND FIRE on their minds, Canadian government officials held a news conference on June 5 to alert residents to ongoing dangers of the wildfire season. As a hazy orange pall of smoke hung in the skies, the government geared up for what it feared would be an unprecedented wildfire

season—with 10 times as much land burned so far in 2023 compared to 10-year averages.

Prime Minister Justin Trudeau told reporters that fire forecasts suggested Canada could be in for a historically bad summer, particularly in areas outside of Canada's usual wildfire hot spots.

"Our modelling shows this may be an especially severe wildfire season throughout the summer," Trudeau said.

That modelling indicated much of Canada faced well-above-average risk for wildfires this season. Crews had battled 2,214 wildfires burning just over 3 million hectares (7.4 million acres) by this point in the wildfire season, which typically stretches from May until September. Canada's 10-year average—for the entire season—had been sitting at 1,624 fires burning around 254,429 hectares (628,707 acres) during a typical season.

The difference was staggering.

In June, nearly the entirety of Western Canada registered at a well-above-average risk for wildfires, including nearly all of the Northwest Territories and Northern Ontario, a large swath of Southern Ontario from Windsor north through Toronto and the Golden Horseshoe, and extreme western portions of Quebec.

Forecasts for July and August proved nearly as intense.

Bill Blair, then Canada's emergency preparedness minister, reported that 413 wildfires had burned across Canada as of June 5, with 249 considered out of control. According to the Canadian Interagency Forest Fire Centre, Quebec was fighting 161 wildfires, with another 69 in Alberta, 62 in B.C., and 45 in Ontario.

"The images we have seen so far this season are some of the most severe ever witnessed in Canada," Blair told reporters.

Those images? They can only be described as hell, said one Nova Scotia resident as she tearfully talked to reporters and described her experience: "Flames were everywhere. They took everything—my home, my clothes, my car . . . my cat."

The federal government warned the worse may be yet to come.

"The current forecast for the next few months indicates the potential for continued higher-than-normal fire activity," Blair said.

Air quality advisories continued to be issued across much of Southern Ontario and into the United States, courtesy of smoke billowing in from fires in Quebec.

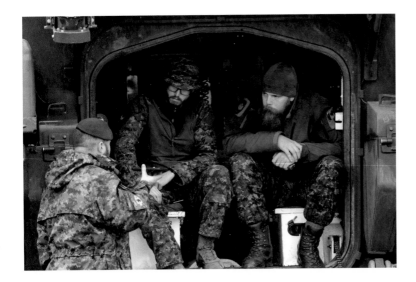

While dealing with wildfires is a provincial responsibility, the federal government said it would provide varying levels of assistance, including over $300 million to provinces to procure firefighting equipment and conduct training. Just under 200 interagency firefighters were deployed across Canada through mutual aid agreements and were helped on the ground by 957 international firefighters from the United States, Australia, New Zealand, and South Africa.

"We are expecting further deployments from these countries, including France, in the coming days and weeks," Blair said, noting that additional crews from Costa Rica would soon land. More help would also arrive from the military. Blair announced that portions of the Canadian military were dispatched to bolster firefighting efforts, including 150 soldiers each fighting blazes near Fox Creek and Fort Chipewyan in Alberta, and in fire-stricken portions of Quebec.

Military specialists also headed to Nova Scotia, joining a 200-person rapid response team from the Second Battalion of the Royal Canadian Regiment based out of CFB Gagetown, N.B., which had just completed wildfire training. Part

of the government's efforts included training more firefighters across Canada and establishing partnerships with First Nations communities to hire and train wildland firefighters and fire guardians.

The situation is "sobering," said Natural Resources Minister Jonathan Wilkinson, adding that every province and territory across Canada needed to be on high alert.

More than 120,000 Canadians had already been forced from their homes at this point in the season, with 26,206 people currently under evacuation orders in B.C., Alberta, Saskatchewan, Quebec, Nova Scotia, and the Northwest Territories. Many, the prime minister said, only had a few hours' notice that they were being ordered to leave their homes.

"Year after year, with climate change, we're seeing more and more intense wildfires, and in places where they don't normally happen," Trudeau said. "If things get worse, we are developing contingency plans and we will of course make sure we are there . . .

"Whether it's leaning more on international supports, whether it's standing up other resources, we will be there to ensure that all Canadians are protected through the summer."

IN EARLY JUNE, the massive Nova Scotia fires that had started near the end of May still endangered thousands. Many evacuees, however, anxiously awaited word whether their homes had survived the flames. Thus, officials arranged bus tours for Halifax-area residents—who had lost their homes—to view fire-struck areas deemed safe. Ash and smouldering rubble littered the ground where their houses once stood. The Halifax fire destroyed about 200 structures, including 151 homes, while the Barrington Lake wildfire further south claimed 150 buildings, of which 60 were homes.

International media turned their lenses north, documenting the devastation. *The New York Times*, for example, told the story of Heidi MacInnes, the owner of Restless Pines Farm equestrian centre and a resident of Hammonds Plains, an area affected by the Nova Scotia fire. She recounted how harrowing it had been to evacuate her home with her partner, her 22-year-old daughter, and their 57 horses.

"There were burning embers falling in my driveway," she told *The Times*. MacInnes put out a call on social media for help transporting the horses and was taken aback by all the offers of hay, water, and horse transportation trailers. "I guess the most important thing to take away from this is the value of people helping each other in times like this," she was quoted as saying.

The New York Times wasn't the only American news organization reporting on the Canadian wildfires. Several reported on a media briefing in which Halifax Mayor Mike Savage looked toward the sky and noted that the forecast called for rain—something he'd been praying for.

"If you happen to know the Almighty, talk to her," Savage said. "Put in a good word for us."

ABOVE Crew members attend a morning briefing June 1, 2023, at the Shelburne County municipal building, as Nova Scotians ramped up their fight against massive fires. (Photo courtesy Communications Nova Scotia)

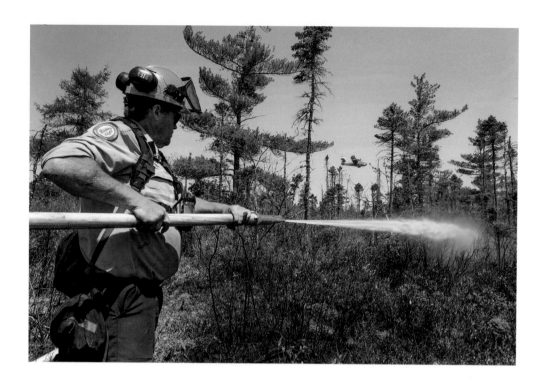

The rain did arrive—in disastrous amounts about 6 weeks later. A downpour of between 250 mm to 300 mm (10 to 12 inches) fell in just 24 hours, leading to deadly flash floods in areas including Halifax, West Hants, East Hants, Lunenburg, and Queens. Nova Scotia was ironically facing another state of emergency, this time for flooding. Four people, including two children, died in the rushing waters.

The wildfire-related state of emergency in Alberta, meanwhile, was lifted by early June, but several fires still threatened communities. The 9,000-person town of Edson (about 200 kilometres, or 125 miles, west of Edmonton) was evacuated—for a second time. Residents had faced a mandatory order to leave town in early May due to nearby wildfires. They returned home May 8, but now a fire south of the town had grown to 204,000 hectares (504,000 acres). It burned only 2 kilometres (1.2 miles) from the town, so they evacuated again. Just two days earlier, officials planned to wind down

emergency response operations. The head-whipping change of the fire's status showed the volatility of the situation.

"Anything we can do that actually would allow for the protection of your home is what we're doing, so we hope you understand that that's what's happening," said Christine Beveridge, chief administrative officer of the Town of Edson.

Crews created structural guards in town as they moved combustible items from homes, such as barbecue propane tanks and hanging plants.

"These fires are still on our doorstep, and they will have the ability to be a significant danger in a matter of minutes," said Yellowhead County chief administrative officer Luc Mercier. "We cannot guarantee people's safety, and we cannot take the evacuation order down until we have that assurance."

While the province no longer sat in a state of emergency, it was definitely still in crisis. By the second week of June, Alberta was well on track to record its most devastating wildfire season ever, which could last another 3 months. There had been 629 wildfires so far and, of those, 357 were suspected to have been caused by people (mostly accidental), and 122 by lightning, with 150 still under investigation.

THE BC WILDFIRE SERVICE also warned that the season would be full of challenges, noting the Donnie Creek wildfire had erupted into the largest blaze on record in that province by June 18. Previously, the 2017 Plateau fire that charred 5,210 square kilometres (2,011 square miles) northwest of Williams Lake was considered B.C.'s largest fire. Now the Donnie Creek fire, burning south of Fort Nelson in northeastern B.C., became the largest ever, at more than 5,343 square kilometres (2,062 square miles) in size. That's bigger than the size of 30 countries.

FACING Department of Natural Resources and Renewables firefighter Walter Scott of Churchover, Nova Scotia, sprays the ground as a water bomber flies by to dump a load of water on the fire, in Barrington Lake on June 1, 2023. (Photo courtesy Communications Nova Scotia)

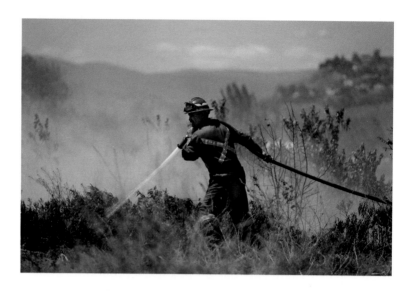

A fire that big, with a 900-kilometre (559-mile) perimeter, proved difficult to extinguish, so firefighters instead worked to protect homes and infrastructure in the area. By using controlled burns, they hoped to steer the fire toward rivers, lakes, and areas that burned in previous years, trying to direct it away from the bone-dry conifers in the boreal forest. It could be winter before the fire would be snuffed out, firefighters said, but it also had the potential to smoulder underground and re-emerge next year.

This Donnie Creek wildfire counted as only one of about 80 fires burning across the province that week. BC Wildfire Service information officer Marg Drysdale said crews focused on protecting infrastructure and the Alaska Highway, but she expected the blaze to continue to grow throughout the summer.

"We will have crews on it into the fall," she noted.

The service listed Donnie Creek as out of control, noting it was highly visible and could pose a threat to public safety. More than 250 BC Wildfire Service personnel, including 152 firefighters, laboured to control the blaze. Drysdale

explained the fire started from a lightning strike, but its massive size was the result of about 8 fires growing quickly and merging into one giant blaze.

"It's really important for people right across the province to understand that we have not hit the fire season that we normally see in July and August," she said. "We're in the middle of June. If conditions continue as they have, if we get a hot summer, we are going to see more impacts."

Other fires took their toll in British Columbia throughout the month. The West Kiskatinaw fire saw 2,000 people evacuated from their homes in Tumbler Ridge in northeastern B.C. Another out-of-control fire shut down Highway 4 on Vancouver Island, disrupting traffic and causing many visitors to stay away from the west coast of the island. The manager of the Long Beach Lodge resort said the facility had a "significant" loss of bookings due to the Cameron Bluffs blaze—just another one of the economic hardships wreaked by wildfires.

"We're normally 80 percent full this time of year, but we've lost up to half of our bookings since the wildfire," said Samantha Hackett, who has lived in the community for 15 years. "I've never seen anything like this. Road closures usually occur as a result of washouts because of winter storms, during our slow season. It's never been just before summer from wildfire."

The fire also loosened debris on a slope and nearly a dozen trees—some up to a metre in diameter—toppled onto the highway, said the Transportation department. Transportation Minister Rob Fleming noted that geotechnical engineers needed time to monitor the cliff face above the highway to ensure its stability before it could be reopened to traffic.

"I understand the closure has created a major challenge for locals, businesses, and tourists, and we are anxious to get the road open as quick as possible," he said. "But obviously safety

is our number-one priority, and we cannot reopen the highway until we know that the travelling public will be safe."

Janelle Staite, the ministry's deputy director for the South Coast Region, added: "Even today, we are seeing rocks the size of coffee mugs coming down onto the highway."

The wildfire-related issues caused a pack of predicaments for visitors and potential visitors to the area. For Savannah Kreutziger and Jesse Lee, they now faced more stress than they ever anticipated would accompany their wedding day. The Prince George, B.C., couple planned to marry on Tofino's Cox Bay beach in front of 40 of their closest friends and family. Now they rushed to find another spot to say their vows.

"We're choosing to relocate our wedding for the safety of my guests and the residents of Tofino. We didn't just want to go there, take everything, and then leave," said Kreutziger. "These people are already facing fuel and grocery shortages."

The 28-year-old also expressed fear of the fire getting worse.

"What if we all get stuck there? What if the logging road closes down again? . . . Our guests are renting vehicles, and none of our elderly guests feel safe driving 4 hours on a logging road," Kreutziger said. "If our wedding was way smaller, I would say let's all just fly in—but we cannot afford that." The bride estimated she was facing close to $4,000 in losses from the deposits she made for catering, wedding planning, photography, and other services.

"At this point, I'm pretty defeated and sad. We've been planning this day for over a year, and Tofino was my dream spot."

Travellers affected by the highway's closure say the wildfire made them realize that a single highway into the popular coastal communities isn't enough to accommodate the levels of visitors during the busy season.

"The province needs to create another highway so this doesn't happen again," Kreutziger said.

IN SASKATCHEWAN, the busy wildfire season left some remote structures such as cabins and sheds in ash and embers, but flames hadn't yet entered any communities. Evacuation orders continued emerging in June to keep people out of harm's way. A state of emergency occurred as a wildfire neared the northern community of Buffalo Narrows. Left without power and with smoke choking the community, residents headed out. The northern village of La Loche, meanwhile, dealt with its second fire evacuation of the year in early June, but the Saskatchewan Public Safety Agency (SPSA) worked to bring people back home as quickly as possible.

"The weather that we're currently experiencing allowed crews to switch from indirect to direct attacks and put more

resources on the line, securing those critical boundaries that are near the communities," said SPSA vice-president of operations Steve Roberts. "So even though there remains a smoke hazard, the physical threat to those communities has been reduced, and local leadership has made decisions to bring (people) from their communities back—other than those who have critical medical conditions." Travel advisories lifted for the areas in and around Besnard Lake, north of the Churchill River, and near Montreal River.

"Fires no longer pose a threat to travellers, boaters, and paddlers in those areas, but we want to remind anyone in those areas to remain diligent in preventing fires," said SPSA president and fire commissioner Marlo Pritchard.

Meanwhile, near the hamlet of Dillon—a 5-hour drive north of Saskatoon—fire crews laboured to contain all the hot spots on the northeast side of the more than 60,000-hectare (148,000-acre) fire. On the northwest of the fire, workers built helicopter pads to accommodate aircraft that could aid in air assaults on the blaze.

Twenty active wildfires burned in the province as of June 2, and crews were stretched thin. All the personnel and equipment fighting wildfires in the province were local to Saskatchewan. One aircraft on loan from Quebec the previous week had now been returned. Roberts said the agency needed to check to see what other crews from outside the province might be available, because they would be needed in the days and weeks ahead. Bringing in more crews and equipment, however, could be a challenge, as Nova Scotia and Alberta were still battling intense fires as well.

"Having a large number of fires this early in the season has stretched our capacity," so Saskatchewan may also need some help, said Roberts. "We may have to bring crews in just to give our crews a chance to get off the line and get some downtime before we put them back to work. They have been going hard at it for well over two-and-a-half weeks, so we may have to look at some relief just so they can get refreshed and get back on the line here because these fires won't be over anytime soon. We have a full season ahead of us."

ABOVE Residents across Nova Scotia opened their hearts to victims of the wildfires and donations poured in. This is just one truck that was filled with donated clothing and other essential items. (Photo courtesy Communications Nova Scotia)

UNDER A STRANGE, apricot-coloured sky, Ottawa's air quality readings in early June hit levels more commonly seen in some of the most polluted cities in the world, as smoke from wildfires continued to create widespread health risks.

"It is terrible. I have lived in Ottawa since 1996 and I have never seen a day like this," said Dr. Shawn Aaron, a respirologist at the Ottawa Hospital. Aaron predicted emergency departments would likely see a spike in visits in the coming days related to the extremely poor air quality, which could increase the risk of heart and lung problems, especially in the elderly, very young children, and those with chronic illnesses. Health officials were advising people to wear N95 masks when outside, to limit their time outdoors, and to keep their windows closed and air conditioning on.

"If you must spend time outdoors, a well-fitted N95 mask can help reduce your exposure," said Monica Vaswani, a warning preparedness meteorologist with Environment and Climate Change Canada. "A mask would be your best defence if you do have to be outdoors."

In Ottawa, the risk level spiked as one of the key measures of poor air quality hit new highs. The amount of fine particulate matter ($PM_{2.5}$) in Ottawa's air usually measured in the range of 4 to 11 micrograms per cubic metre. When that reading hit 60, Environment and Climate Change Canada issued its new air quality warning.

Within a day, however, that number more than quadrupled to upward of 260 micrograms per cubic metre—a reading considered very unhealthy. Beijing, which in the past has experienced some of the worst air quality in the world, registered a moderate 61 that same day. Because the World Health Organization recommends levels of 15 or less, health experts were

worried. Dr. Tom Kovesi, a pediatric respirologist at the Children's Hospital of Eastern Ontario, said the air quality was a risk to everyone.

"This is extraordinary," Kovesi said. "I looked out the window this morning and the air was yellow. It was bright yellow. This does affect potentially everybody."

Reiterating earlier warnings, Dr. Aaron noted the fine particles could get deep into people's lungs and bloodstream and cause inflammation. People with asthma, COPD (chronic obstructive pulmonary disease), or other chronic lung diseases were at increased risk of additional inflammation and may become wheezy or short of breath. The fine particulate matter can also cause inflammation throughout the body that can trigger health events such as blood clot formation, angina, and heart attacks in people at risk. Some studies have also linked premature births and increased mortality with exposure to forest fire smoke. Aaron added that fine particulate matter readings were something he normally didn't think about.

"In a city like Ottawa, which has a lot cleaner air than a place like Beijing, we don't even pay attention to this," he said.

"But, on a day like today, it becomes important for lung physicians. It is going to explain why we are going to see people getting sick."

SMOKE CONTINUED TO SMOTHER Quebec, too, as fires advanced. Worry hung heavy in the air, along with the haze.

"On June 1, lightning strikes from several isolated thunderstorms led to the ignition of over 120 fires in just one day, mostly in the western and northwestern parts of the province," said Yan Boulanger, a research scientist at the Canadian Forest Service, Natural Resources Canada. Many of these fires burned for several weeks, and continued burning into August, exacerbated by sporadic bouts of warm, dry, and windy conditions.

By June 5, evacuation orders landed for 5,500 people in the Abitibi-Témiscamingue region near the Ontario border and 4,500 in Sept-Îles, a North Shore community. The number of fires in the province jumped to 141, with 35 being actively fought by teams from SOPFEU (Société de protection des forêts contre le feu)—the Quebec forest fire prevention organization.

"We concentrate our battles on these fires because we want to protect human life, the houses, and enterprises. And we want to protect our infrastructure, like Hydro-Quebec's," said Public Security Minister François Bonnardel.

More than 475 SOPFEU firefighters worked the fires, joined by hundreds of soldiers and 100 personnel arriving from France. With parched trees providing ample fuel for flames, firefighters proved relentless in what would have been a futile fight without their heroics.

"We are facing a situation that has never been seen," said Natural Resources and Forests Minister Maïté Blanchette Vézina.

As government officials gathered for a news conference to address the crisis, Premier François Legault said the entire summer could be under threat of fire.

"It's unheard of that we see so many as this," Legault said of the fires at a news conference. "We are going to be in this for a long time . . . We're talking the summer if we want to be sure all these fires are out. This is why in the short term we're asking for help."

By June 6, wildfires in Quebec numbered 164 and more than 10,000 residents sought temporary shelter as flames threatened their homes. Another 2,100 people from

Lebel-sur-Quevillon fled the fires the next day. This was the worst early-season forest fire outbreak in the province's history, resulting from a perfect storm of meteorological conditions. An estimated 158,000 hectares (390,000 acres) of forest had burned, more than 600 times the amount normally consumed by this point in the season and 10 times the average for an entire year.

The size of devastation and number of fires stunned the country.

Because Quebec had the resources to tackle roughly 30 forest fires at a time, more than 100 of the fires burned out of control. Fires became prioritized based on their proximity to communities and to crucial infrastructure like power lines and bridges.

"It is historical," said Karine Pelletier, a spokesperson for the SOPFEU. "We have never seen that number of fires at the same time."

The infernos were due to "all the ingredients being there simultaneously," she said. "Very low humidity, no rain, strong winds, and many thunderstorms and lightning strikes."

Among the largest was the blaze near Sept-Îles, 900 kilometres (559 miles) northeast of Montreal on the north shore of the St. Lawrence; it burned through 32,000 hectares (79,073

acres) by June 5. Shifting winds and lower daily temperatures eventually reduced the risk to the city of 28,000 residents, but more than 4,500 remained away from their homes, threatened by nearby fire. At certain points of the blaze, the fire moved forward at a rate of 5 kilometres (3 miles) a day.

Smog conditions became so heavy in Sept-Îles that Environment Canada issued a special air quality alert due to the high concentrations of fine particulate matter present. Residents received the advisory to stay indoors with doors and windows closed, and to wear a respirator-type mask if venturing outside.

Reinforcements arrived to combat the conflagration. Nearly 200 Canadian Forces military personnel were sent to help, along with Sûreté du Québec officers.

Meanwhile, Mike Norton, director general of the Canadian Forest Service with Natural Resources Canada, said climate change increased the frequency and intensity of wildfires, creating longer fire seasons. Wildfires represent the second most expensive disaster in Canada, after flooding, costing more than $1 billion annually to combat, he noted. That number, however, skyrocketed with each passing day in 2023.

To this point in June 2023, Canada had experienced 2,114 fires that burned close to 3.3 million hectares (8.2 million acres) of forest. Meteorological projections for warm and dry conditions during the remainder of summer suggested the potential for higher-than-normal fire activity would continue across the country, Norton said.

"We are experiencing an unprecedented amount of fire for this early in the season. If this rate continues, we could hit record levels for the area burned this year," he said, accurately foreshadowing future figures.

FACING As the fires continued raging through Canadian forests, reinforcements continued arriving from around the world, including this group of wildland firefighters from Chile and Costa Rica showing their flags at a June 2023 orientation session in Alberta. (Photo courtesy Alberta Wildfire)

By this point, close to 3,000 Canadian firefighters tackled the blazes nationally, officials said. In Quebec, many of the fires were fought with water bombers because of the large number of lakes in the province, Pelletier noted. Firefighters also plowed down large sections of forest with bulldozers to create open spaces, hoping to impede fires from progressing, and then using hoses to extinguish nearby fire.

Roughly 950 firefighters and management personnel from the United States, Australia, New Zealand, and South Africa arrived to help fight flames. Canada possesses international agreements with these countries, some of which ideally have firefighting seasons that don't overlap with North America's. The scope of the fiery season demonstrated, however, that additional agreements would likely need to be signed with other nations, said Trudeau.

While the majority of the early-season fires in Quebec started due to lightning strikes, Pelletier noted that, in a regular season, human activity causes roughly 80 percent of fires. That's why citizens were urged to do their part by not lighting campfires, being cautious with cigarettes, and not entering forests in several regions of the province where entry was prohibited: Northern Quebec, Abitibi-Témiscamingue, Outaouais, Côte-Nord, Mauricie, Saguenay-Lac-Saint-Jean, the Laurentians, and the Lanaudière region.

DID CANADA HAVE ENOUGH *firefighting personnel and equipment to deal with its record wildfires?* The question swirled as fire after fire after fire sparked across the country.

In Quebec, for example, SOPFEU discussed how it only possessed enough resources to fight 30 of the 150-plus forest fires burning across the province, giving priority to those posing

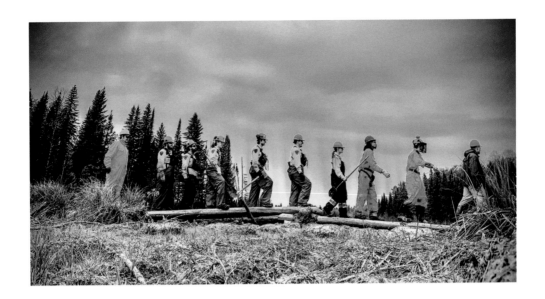

the most risk to communities and electrical infrastructure. The rest were left to burn uncontrolled.

At the time, Quebec had 520 SOPFEU employees fighting fires on the ground. That included 240 full-time firefighters and 280 auxiliary firefighters who normally work for other companies but received calls into active duty. Up to 200 Canadian military personnel and about 500 more firefighters from New Brunswick and France were added to that, with negotiations occurring to get more personnel from the United States, Spain, Portugal, and Mexico.

Altogether, that would be about 1,200 more people, which would help fight about 40 fires, officials said. Quebec Premier François Legault said SOPFEU also possessed 13 water bombers, two of which were pulled out of service for mandatory inspections. Two water bombers obtained from Yellowknife in the Northwest Territories and four aircraft from U.S. suppliers began being used as reinforcements.

The number of personnel raises concerns, said Andrés Fontecilla, the Québec Solidaire critic for public security, introducing a motion in the National Assembly and expressing worry

that SOPFEU only had the resources to fight less than three dozen fires. Fontecilla requested that the government "in the framework of its efforts to adapt to climate change, increase SOPFEU's ability to intervene."

Other Canadian politicians agreed change needed to happen. Some suggested Canada mirror the example of France, which has 200,000 volunteer firefighters enlisted to help in the case of wildfires or other emergencies. SOPFEU spokesperson Karine Pelletier noted that in normal years, the interprovincial agreement that allows the sharing of firefighting personnel meets normal needs. But this year's wildfire season couldn't be described as "normal."

"Never before did we have a situation where all the provinces had needs at the same time," she said. "Normally, the fire period varies from east to west. But this year it's very different."

SOPFEU keeps 600 auxiliary firefighters on call, typically employees of forestry companies that have agreements with SOPFEU to free up their workers when needed. Auxiliary firefighters need to do 3 days of accelerated forest firefighting training and pass physical exams in order to qualify.

To respond to the unprecedented crises that could become more commonplace due to global warming, the federal government began studying options for creating a new national disaster response agency, the Canadian Press reported. Plans included analyzing whether to create a Canadian version of the American Federal Emergency Management Agency. Canada's disaster response plans involve different levels of government, but officials repeatedly turn to the Canadian Armed Forces to help in these situations by deploying soldiers and equipment.

"The reality is, unfortunately, over the past years we've seen extreme weather events increase in their intensity and [in]

their impact on Canadians, as well as on their cost to families, to provinces, and the federal budget," Prime Minister Justin Trudeau said.

"We need to continue to make sure we are doing everything possible to both keep Canadians safe . . . [and] to predict, protect, and act ahead of more of these events coming."

Bill Blair, then the federal public safety minister, noted that by June 7 there had been three instances in which provinces indicated the wildfire situation they faced exceeded their capacity to fight it.

"We also recognize that there's a need in all the provinces and territories in every part of the country for additional fire-fighting resources," which is why Canada was investing in the training of 1,000 new firefighters, he said.

As the days of June passed, Quebec wildfire challenges continued. Residents in three rural areas of Val-D'Or, in the northwest of Quebec, received evacuation orders. The province's Forests Minister Maïté Blanchette Vézina again talked to reporters, noting dozens of fires that earlier were considered contained could flare up.

"What we announced, and what will probably happen in the next days, is that fires that were contained—we're talking about 40 contained fires—could go out of control," with

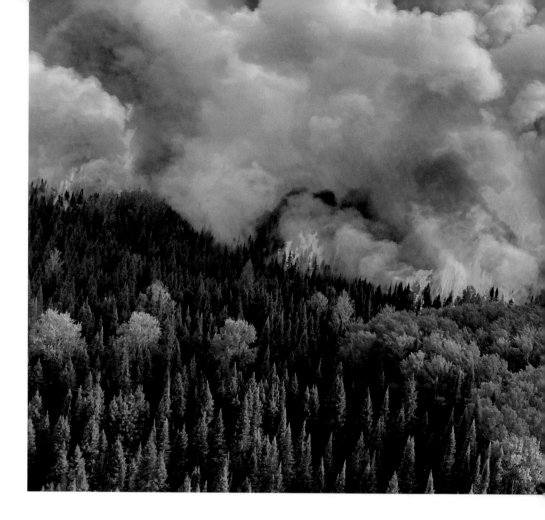

potential hotspots being northern Quebec, the Abitibi region in the northwest, and the Lac-Saint-Jean region, north of Quebec City.

"The situation is critical for the next days," she said. As fires edged closer to communities, more evacuations occurred, including several hundred people from Indigenous communities, 530 workers at a gold mine, and 190 workers at hydro stations.

By the end of the month, the city of Montreal held the dubious distinction of having the worst air quality in the

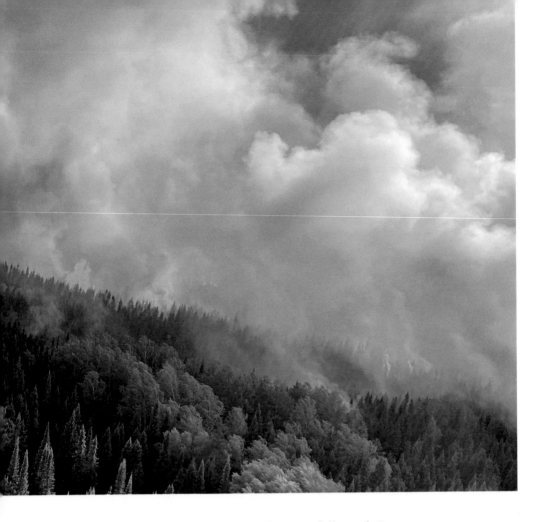

world. A series of closures and cancellations followed. Just an hour before it was set to begin, officials paused the Mont-Tremblant Ironman 70.3 triathlon, citing strict criteria required to hold Ironman events. Unfortunately, the air quality meant the venue could no longer meet those criteria.

More cancellations occurred. Fearing a wayward spark would start another blaze, desiccated conditions across the country caused many communities to cancel planned firework displays for the June 24 Saint-Jean-Baptiste holiday and for July 1. It was Canada Day, but Canada was on fire.

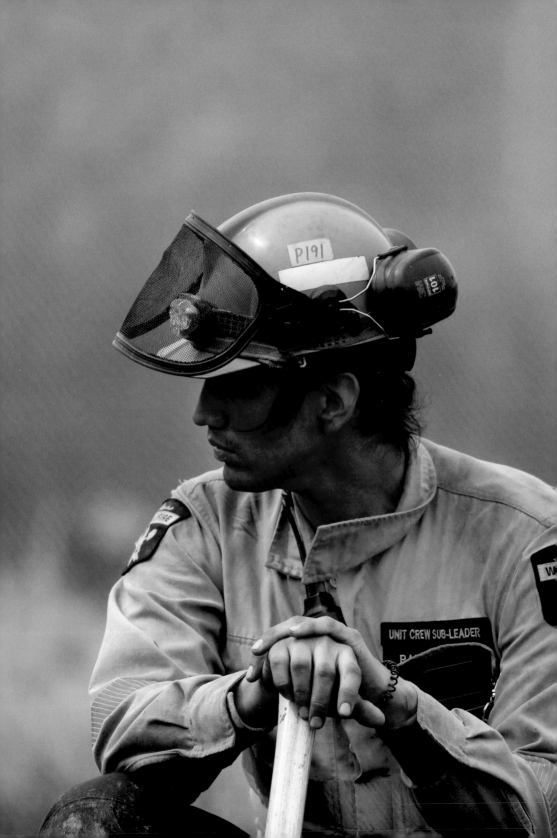

JULY

THE FIREFIGHTERS

THOSE WHO RUN toward danger when others run away deserve unquestionable gratitude. When those actions lead to their death, those individuals become heroes. Tragically, four Canadian firefighting personnel earned that designation in July 2023.

Devyn Gale was the first. The 19-year-old was a firefighter with the BC Wildfire Service, just like her brother and sister. While brush clearing in a remote fire area near her hometown of Revelstoke on July 13, Gale's firefighting team lost contact with her. They later found Gale pinned under a fallen tree, but she succumbed to her injuries after she was airlifted to hospital.

"Devyn, you're one of the best people I know . . . You're an inspiration and a hero," her brother, Nolan, said at a celebration of Devyn's life. He also expressed gratitude for the few minutes he was able to spend with Devyn at the end of her life. He'd been working nearby and had helped pull her from beneath the tree.

His sister, Kayln, also honoured Devyn, calling her a compassionate, motivated woman. Devyn had been studying nursing at UBC Okanagan.

"Her heart was also open to enrich hers and others' lives . . . She made my world sparkle with colour," Kayln said. "Rest easy knowing we'll never forget you."

FACING The work of firefighters is both physically and mentally exhausting. Pictured is a wildfire worker deployed near Sturgeon Lake Cree Nation in Alberta. (Photo courtesy Alberta Wildfire)

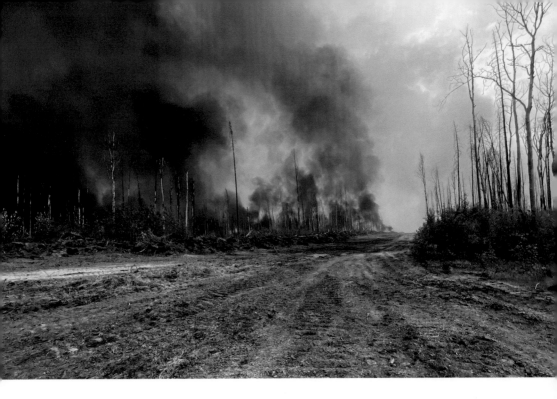

Hundreds lined the streets of Revelstoke to honour Devyn's memory, with members of the BC Wildfire Service, local fire departments, and RCMP joining a solemn procession.

Colleague Stefan Hood said Devyn always had a smile on her face and that she was "immensely beautiful and full of life." He described her as a "gale force" who loved her job and was always up for an adventure.

"I wonder if, like me, she planned her next camping trip based on the newly discovered landscape that unfolded before her with every flight to a fire. I wonder how many of those adventures remain planned and shelved, ready but never lived."

Just two days after Devyn Gayle's death, 25-year-old firefighter Adam Yeadon was also killed by a falling tree. The accident occurred at a fire near his home community of Fort Liard, Northwest Territories. Relentless heat had beat down on parts of northern Canada throughout July. Record-breaking and

earth-baking temperatures had robbed the soil of what little moisture existed. By mid-July, almost 100 active blazes had raced through the Northwest Territories as firefighters battled flames. July 15 would be Adam's last battle.

Adam—a loving partner, brother, son, and father to a two-year-old daughter—found firefighting work a fulfilling pursuit. He made a difference by helping to protect forests, the land, and, at times, even people's homes.

"He had peace in his heart. He had peace in his mind, and he died happy," his father, Jack Yeadon, told the Canadian Press. "He died doing the job that he loved."

Leaning on the poignant beauty and wisdom of Indigenous teachings, Jack recalled the spectacular thunderstorm that occurred a day and a half after Adam's death. "I was connected to that storm," Jack said. "I think it was the universe saying, 'Jack, we are with you. Your son is up here, and he is powerful.'"

Adam's death was the first firefighter fatality in the Northwest Territories in more than a half century. Prior losses had occurred in 1971, when four firefighters had died in an aircraft accident and two others had died from injuries caused by falling trees.

The 2023 accidents sent waves of sorrow through the firefighting community. Governments and forestry groups across the continent expressed condolences to the families and friends of the fallen firefighters.

"The past week has been devastating for wildfire responders across the country," Yukon Premier Ranj Pillai, Community Services Minister Richard Mostyn, and Yukon Wildland Fire Management said in a joint statement. "We are holding them, their colleagues, and their loved ones in our thoughts as we mourn along with our neighbours."

FACING This photo, taken on July 5, 2023, shows flames near a fireguard that was constructed to prevent the spread of the Basset Complex wildfire in northern Alberta. (Photo courtesy Alberta Wildfire)

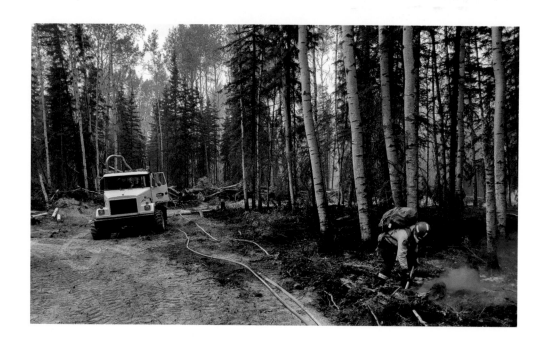

ABOVE Firefighters and heavy equipment crews work to control lines on the southeast side of the Basset fire in Alberta on July 2, 2023. (Photo courtesy Alberta Wildfire)

Tragedy persisted when a third person battling the blazes died. Pilot Ryan Gould was assisting in the firefight 140 kilometres (87 miles) northeast of Peace River in Alberta when his helicopter crashed on July 19.

The 41-year-old left behind his wife, Carlyn, and their two sons.

Kassy Goodyer, a family friend from Drayton Valley, said Carlyn always spoke highly of her husband.

"He was a very private person, but he had such a big heart and would help anybody," Goodyer said, adding that Ryan was a good dad to his boys, Gus and Evan. "He did everything in his power to make sure the boys and Carlyn were comfortable when he was away, and he made sure everything they needed was taken care of."

Ryan had fought fires in Canada, as well as in Australia in the off-season. Although he and his wife had lived in the Calgary region for a time, Whitecourt—northwest of Edmonton— was Ryan's hometown and where they'd settled down. Carlyn

had been boarding her horses, and the couple had worked toward their dream of acquiring an acreage, Goodyer said.

When searching for land, they'd found "the perfect place" south of town, in the Anselmo area. Friends now wanted to help Carlyn keep this farm. Following the crash, an online fundraiser began on the website GiveSendGo, which raised more than $256,000 by the end of August. Goodyer said she'd collaborated with others from the Drayton Valley area to get the crowdfunding underway. Ryan had worked with Drayton Valley residents during the wildfires in the spring, creating a connection they wanted to honour.

"I never expected it to get that big, and it moved me to tears," Goodyer said. While the crowdfunding campaign was taking off, members of the Gypsy Vanner horse-breeding community also wanted to contribute something. The idea was hatched to hold a silent auction via social media, with services and donated items—including stallions—put up for bid.

The support overwhelmed the family, with Carlyn writing on Facebook: "My heart is shattered as the boys and I grieve the loss of our husband and dad, but also full from the out-pouring of support that is helping to ease the financial burden this tragedy created.

"Someday, when we are in a position to do so, we will make sure to pay it forward," she said. "I will miss him forever, but I would not give up the blessed 17 years we had together to avoid the pain of this grief today and the rest of my days. He was worth it. It was an honour and a gift to stand by his side as his wife."

Then—just when the fire community thought it could take no other losses—a fourth firefighter fell in the line of duty. Originally from Waterford, Ontario, Zachery (Zak) Freeman Muise died July 28, just one day before his scheduled days off would have begun. In a remote area about 150 kilome-tres (93 miles) north of Fort St. John, B.C., Muise suffered fatal injuries when his utility vehicle rolled over a steep drop. A helicopter transported the 25-year-old to hospital, but he passed away en route.

At a public memorial in Penticton, B.C. (where Zak's employer was headquartered), hundreds of friends and fam-ily members, including his parents and siblings, celebrated the life of a young man who had always stood ready to assist those around him. Full of heart-wrenching pride for Zak's choice—a life of service—the family said the loss could only be described as devastating.

"Zak loved life and loved what he was doing. He will be missed by all who know him," the family said in a statement. "We are so grateful for the time we had with him. We are grate-ful for all first responders. Our hearts go out to all the families

of fallen firefighters, first responders, and those left who are still fighting."

The memorial included a stirring procession of firefighters and colleagues, led by a bagpiper, and remarks from Penticton mayor Julius Bloomfield: "Today is a difficult day. It is a difficult day for the family. But I look around and I see that Zak probably had at least two families. He had a family that he belonged to, but he had the family who adopted him, the B.C. wildfire fighters.

"We are here to acknowledge the service that this young man gave and the ultimate price that he paid," Bloomfield said, turning to the family and adding: "Thank you for raising a son who is prepared to help others and headed toward danger in order to protect others."

The Donnie Creek wildfire that Zak fought would no longer only be known as the biggest fire to ever strike B.C. Now, it was also a blaze that led to the death of a firefighter.

Sadly, four more firefighters would die in B.C. during the wildfire season, after their vehicle collided with a semi-tractor trailer in September as they were travelling home from a firefighting scene in the centre of that province.

"First responders play a critical role in safeguarding lives and communities," said the Public Service Alliance of Canada. "Unfortunately, incidents like these remind us how dangerous this work can be."

TO MITIGATE DANGER, wildland firefighting requires careful coordination. Designating resources requires strategy, much like a chess game. Wildfire officials consider what they need

to protect, how they can get ahead in the game, and how they can defeat their opponent.

Firefighting falls within provincial and territorial jurisdictions in Canada. Despite that division of responsibility, wildland firefighters form a tightly knit community across the country. They stay in close contact, ready to head west, east, or north, depending on where the most urgent firefighting need exists. Much of that coordination comes from the Canadian Interagency Forest Fire Centre (CIFFC), a non-profit corporation owned by Canada's federal, provincial, and territorial wildland fire-management agencies.

"Our mandate is to improve wildland fire response, prevention, [and] mitigation capacity throughout Canada," said Jennifer Kamau, communications manager for CIFFC. "One of the ways that we do that is during the fire season we help the provinces and territories share their firefighting resources." Those resources include equipment—such as pumps, hoses, and aircraft—but also, critically, personnel. The people power involved in battling blazes centres on firefighters, but also extends to a large group of individuals who have expertise in everything from logistics, communication, mapping, transportation, and fire behaviour.

When does a province reach out to CIFFC? "When they've exhausted their resources or they see that they may have a need they can't meet with their own resources, then they come to us and put in a request," explained Kamau.

The vastness of Canada and the number of wildfires faced each season also means that the country often needs to import more personnel from around the globe. The government of Canada possesses agreements with other countries to facilitate international firefighter exchanges, which CIFFC manages and coordinates.

When all hell breaks loose, however, new arrangements need to be made—and fast. And that's exactly what happened in 2023.

"It's an unusual season, it's unprecedented," said Kamau. That meant Canada quickly looked for new partners, bringing in firefighters from South Korea for the first time, for example. Those individuals then needed to acclimatize to a different environment while experiencing a different culture, which presents a series of challenges.

"On the coordination side, [we had] to work with multiple partners and even go beyond the framework of international partners that we have currently to get the resources to the affected regions," she said. "Wildland firefighting is unique in that its community around the world is pretty well connected."

The United States often gets the first call, based on its neighbouring location alone. In 2023, CIFFC worked with 12 countries—the most they've ever used—to bring additional firefighters to Canada. More than 5,000 firefighters arrived from countries including the United States, Mexico, Chile, Costa Rica, Spain, South Africa, France, Australia, New Zealand, Portugal, Brazil, and the aforementioned South Korea.

ABOVE American firefighters–from New Hampshire, Maine, Connecticut, and New York– arrive in Nova Scotia on June 3, 2023, to assist their Canadian counterparts. (Photo courtesy Communications Nova Scotia)

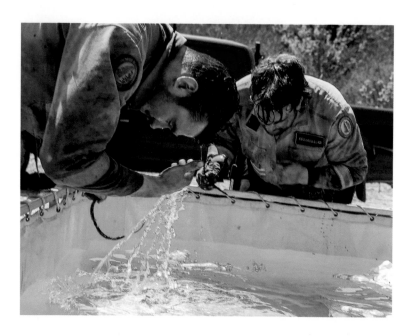

"In terms of international firefighters, it's something that we count on during our fire seasons," said Prime Minister Justin Trudeau, highlighting the importance of these global relationships when speaking to reporters at Canadian Forces Base Bagotville, in Quebec's Saguenay region. "[It's] the same way our international friends and partners count on Canadian firefighters during their fire seasons . . . From northern hemisphere to southern hemisphere, from one region of the world to another, the fire seasons aren't always aligned and that allows for a travelling of resources that is part of how we're going to make sure we're protecting communities all around the world."

INTERNATIONAL FIREFIGHTERS WORKED shoulder to shoulder across the country. In British Columbia, for example, Brazilian firefighters—103 of them—arrived in B.C. in July, joining 500 other firefighters from the United States, Mexico,

and Australia, as about 460 wildfires burned across the province. In the worst wildfire season on record, the international crews provided much-needed relief and assistance to B.C. firefighters.

But just how well did they work together? Quite well, largely due to standard protocols and practices. B.C. provincial fire information officer Mike McCulley said large fires are fought in similar ways worldwide, with an organizational structure that allows crews from one country to assist another.

"Wildland firefighting is significantly different than structural firefighting," he said. Not only are fires bigger and more complex, but they "go on for a long time."

In addition to Brazilian firefighters, there were 100 Mexican and 80 American firefighters in B.C. at the time, including a 40-person parattack crew, sometimes called smokejumpers. There were also 20 American command staff, two American incident-management teams of 28 people, two Australian incident-management teams of 29 people, and an assortment of engine crews and single-resource specialists, with just under 600 "international resources" scattered across the province. Another 102 Mexican firefighters were expected to arrive the following week.

To facilitate an effective firefight, the incident command system provides a standardized approach to the command, control, and coordination of emergency response, allowing a management team from Australia, for example, to arrive at a B.C. fire and relieve a B.C. team.

"The team is very similar and the transition is very smooth," said McCulley. Incident-management teams may bring their own supplies, such as computers, or B.C. may provide them, depending on where the teams are travelling from. Ground

crews will come with their own personal protective equipment, but B.C. will typically provide shovels, pumps, and hoses. B.C. also received firefighting equipment from abroad, such as 10 four-person engine crews from the United States.

When firefighters arrived at the Vancouver International Airport, they were typically taken to a briefing facility before being sent to a specific fire centre where they would receive more information about the fire, type of work they'd be doing, and where they would be staying. After that, they were put to work and integrated into B.C.'s firefighting apparatus.

McCulley said language barriers don't often present a problem, because many firefighters speak some English, although the BC Wildfire Service provides someone to assist if needed. B.C. pays the firefighters, with rates agreed upon before they arrive. The number of international firefighters being used in B.C. was re-evaluated several times a week, he said. Bowinn Ma, B.C.'s emergency management and climate readiness minister, requested 1,000 international firefighters through the Canadian Interagency Forest Fire Centre in July.

ABOVE A fence near the Barrington Lake fire—the largest to ever hit Nova Scotia—became a venue where thanks to firefighters were posted. (Photo courtesy Communications Nova Scotia)

Bonds develop over life-risking work no matter where these firefighters call home. McCulley said he felt it was particularly important to express the gratitude B.C. fire crews felt toward their "brothers and sisters."

"It resonates deeply with us," he said. "We don't take it lightly."

THE UNPARALLELED WILDFIRE SEASON attracted new interest in jobs associated with combating blazes. Even a province like Prince Edward Island, which suffers few fires, saw new firefighting recruits step up. About 70 PEI government workers said they would undergo training that would enable them to fight fires in case of emergencies. But any newbie interested in firefighting should receive this warning: Be ready for bugs, heat, and hard work.

"You have to be used to working in the forest—in places where comfort is secondary," said Karine Pelletier, a communications agent with SOPFEU, Quebec's forest fire prevention agency. "There's often no toilet, there's lots of bugs, it's hot,

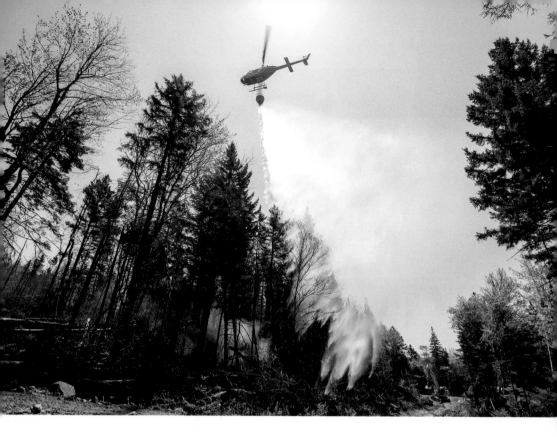

and you have to wear protective gear that gets very hot when you're near a fire."

The days prove to be long, often 12 hours a day for 14 days in a row.

"It's very physical, it's very difficult, so you really have to have a passion for it," Pelletier added.

Location presents another challenge for firefighters. In Quebec, for example, its 240 full-time firefighters must work at least 4 months during the firefighting season that stretches from May to September. They need to live at one of 13 bases spread throughout the province, most of them in the remote north. Free lodging is not provided, but firefighters can live in rented rooms or shared accommodations.

When there's no fire activity, hours are 8 a.m. to 5 p.m. for 10 days on, followed by 4 days off. During fires, firefighters

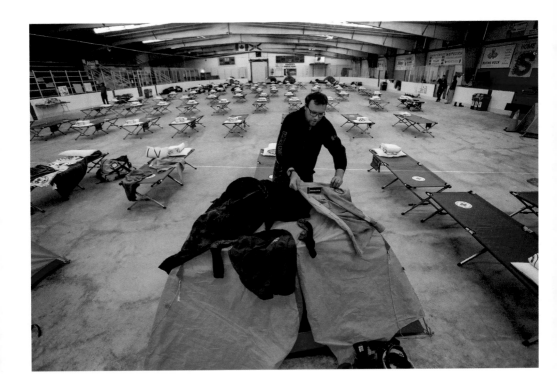

are expected to work overtime, which increases salary significantly. The average salary for firefighters in their third year, with overtime factored in, varies between $29,000 and $55,000 for a season of work. First-year workers get $22.49 an hour.

Firefighters need a high-school diploma and a professional or vocational school diploma, or a college or university degree in forestry, fauna, or fire safety. Or, they can be a college or university undergraduate in those studies, or have had 3 years of forest-related work experience.

For those who don't meet these requirements for a full-time position, another option is to become an auxiliary firefighter via specialized forestry companies. SOPFEU trains about 500 auxiliary firefighters at the start of each season. They are called on when needs are high.

ABOVE Department of Natural Resources and Renewables firefighter Jordan MacRitchie lays out his wet gear to dry for the night on June 4, 2023, at the Shelburne County Arena in Nova Scotia. (Photo courtesy Communications Nova Scotia)

Physical requirements also play a key role. "As the work is physically demanding, forest firefighters must be in good physical condition," SOPFEU says. Applicants must pass a WFX-FIT physical test, which replicates the type of work required when fighting fires. It involves:

· Carrying a mid-sized motor pump on one's back over a distance of 160 metres (525 feet) while crossing a 1.22-metre (4-foot) ramp with a 35-degree slope every 20 metres (66 feet);

· Carrying a mid-sized pump with one's hands over a distance of 80 metres (262 feet);

· Carrying a backpack (containing four hose lengths and weighing 25 kilograms/55 pounds) on one's back over a distance of 1 kilometre (0.6 miles) while crossing a ramp every 20 metres (66 feet); and

· Pulling a weighted sled over a distance of 80 metres (262 feet) to simulate moving a hose filled with water.

All of this needs to occur in 17 minutes and 15 seconds or less to become a SOPFEU firefighter.

Variations in salary, training, and qualifications can occur from province to province to territory. B.C., for example, wants candidates who also show motivation, have a relevant skill set, and attend a new recruit boot camp. In Ontario, applicants need to attend a specialized forest-fighting school (several colleges and businesses offer such courses). But all involved make one thing clear: The job isn't easy.

In recent years, some provinces have faced challenges in retaining wildland firefighters. The job requires great physical and mental toughness, so employee burnout is a factor. Additionally, pay and benefits often aren't comparable to urban firefighting jobs, and many of the positions are seasonal.

Some provinces, like Ontario, have taken new steps to address the issue. "Ontario, like other jurisdictions, is experiencing challenges with the availability of skilled and experienced candidates for wildland firefighter positions," said Evan Lizotte, fire information officer with that province's Ministry of Natural Resources and Forestry. "Therefore, the ministry is exploring and implementing recruitment and retention strategies to ensure the province continues to have highly trained and capable wildland firefighters, operational staff, and support staff."

A consultant specializing in recruitment and retention began working with the ministry's Aviation, Forest Fire and Emergency Services to establish new long- and short-term strategies. Ontario also received international recognition for a sophisticated response and operations system that allows for rapid deployment of wildland fire crews and resources, Lizotte noted.

One of the keys to effectively battling a wildfire—no matter where it starts—is early detection. Reports of wildfires can arrive from a multitude of sources, including members of the public, aerial patrols, ground patrols, fire lookouts, infrared scanning, sensors, satellites, and shared information from energy, aviation, and forestry industries.

When a fire is reported, an initial attack system kicks into gear. An appropriate response team is dispatched, depending on the location of the flames. A "birddog" (observation) aircraft may be the first on scene to make an assessment. Upon arrival, the size of the fire is estimated, and shortly afterward crews take the first steps in an attempt to control it, if possible. An incident commander on the ground will take the lead on the scene. Coordinators in the relevant provincial wildfire centres ensure appropriate resources are assigned to the blaze. Airtankers and helicopters that can drop water and/or fire retardant may be assigned.

On-the-ground firefighters can run hoses toward flames, pumping water from any available lake or river, which is most common in provinces that possess a larger number of bodies of water, such as Ontario and Quebec. When fires occur in drier areas, retardant may be placed around the border of the fire. A controlled burn could occur, too, to get rid of material that could supercharge the main fire if it were to arrive. Using shovels or axe-like tools to dig out hot spots remains a key task that prevents fire from spreading. With larger fires, coordinators may also build a firebreak, likely using bulldozers, to get rid of flammable materials around a building or community and to provide increased protection.

BY MID-JULY, Canada needed a break from the wildfires. Firefighters were exhausted. Evacuees felt drained. And all Canadians had grown weary of smoky skies.

The middle of the month marked, approximately, the halfway point of the wildfire season in many parts of the country. For a couple of provinces, this juncture brought reasonably positive news. Quebec, for the first time since the end of

May, reported that no out-of-control fires were ravaging the province.

In Ontario, late spring and early summer had brought an escalation in fire activity, said Evan Lizotte, fire information officer for the province's Ministry of Natural Resources and Forestry. "We were seeing warmer and drier conditions, combined with heavy and widespread lightning that contributed to an increased fire load. Since then, fire activity has de-escalated significantly following more seasonal precipitation values and temperatures throughout July and early August, resulting in a more manageable fire situation overall."

That early summer activity ultimately caused a significant increase in Ontario's fire stats for the season. At the mid-point of September, Ontario had recorded 704 total fires, compared to 252 during the same period the previous year and the 10-year average of 671. The amount of land burned, however, had dramatically grown. The 2023 season to that point saw 420,000 hectares (1,038,000 acres) burned, compared to the province's 10-year average for the same time period of 163,000 hectares (402,000 acres).

Most areas of Canada remained on high alert. Winds blew and the mercury rose in eastern parts of Newfoundland and eastern Labrador, where wildfire risk increased. Yukon's situation also became more worrisome, as 80 new fires started toward the end of July, leading to the evacuation of several communities as well as a gold mine. In Manitoba, the town of Leaf Rapids, about 1,000 kilometres (621 miles) northwest of Winnipeg, declared a state of emergency as wildfire approached and 350 people needed evacuation. And just about everywhere in the country, haze-heavy air continued to irritate people's eyes and throats.

In Edmonton, gridiron dreams went up in smoke in mid-July when poor air quality forced the cancellation of Football Canada Cup's medal-round games. Saskatchewan was scheduled to play Quebec in the gold-medal match at Commonwealth Stadium, while Alberta and Ontario were set to battle for bronze. There were also two games scheduled to decide fifth through eighth place in the annual tournament for high-school-aged players.

However, dense wildfire smoke blanketed the region, and the poor air quality left Football Canada officials no choice but to call a premature end to the 10-day, 12-game tournament. Football Canada president Jim Mullin said his organization failed the event's stakeholders, including the teams that travelled great distances.

"I was in the hotel confronting shared disappointment with parents and families," Mullin told Postmedia. "Our executive director was actively working on solutions with the local committee, however, we acknowledge our collective failure to adequately assess risks, leading to insufficient contingency plans. The undeniable impact of climate change on our tournaments calls for proactive planning and revised protocols."

Organizers considered busing players to another location in Alberta where air quality would allow for a series of outdoor

games. However, that was not financially viable, and the air quality in much of the province was too poor for most of the weekend regardless.

"Despite economic challenges, our shared duty is to minimize risks. Not playing based on government protocol was the only decision," Mullin said.

The tournament represented one of the dozens of sporting, cultural, and outdoor events cancelled throughout the summer due to wildfires and related poor air quality. The previous month, the Ironman 70.3 race in Mont-Tremblant and the Groupe Copley World Triathlon in Montreal were cancelled, as was a series of rugby competitions in Quebec.

The choking haze from Canadian wildfires also resulted in postponements of several pro sporting events in the United States the previous month, including a game in New York between the Yankees and Chicago White Sox, and a game in Philadelphia between the Phillies and the Detroit Tigers. With air quality rated above hazardous, a women's pro soccer game in New Jersey was called off, as were several minor league baseball games. Even indoor arenas, worried about athletes' health, postponed games, including a WNBA game between the New York Liberty and Minnesota Lynx in Brooklyn. Added to the list of cancellations were outdoor concerts and festivals, along with closures of beaches and swimming pools on the days when smoke was at its worst. At several American zoos, animals were put into their night-time enclosures earlier in the day to protect them from the smoke-filled atmosphere.

Very few positives emerged as a result of the wildfires save, perhaps, one: the crisis was helping to control Alberta's mountain pine beetle problem. Nadir Erbilgin, a professor of forest health and the department chair of renewable resources in the

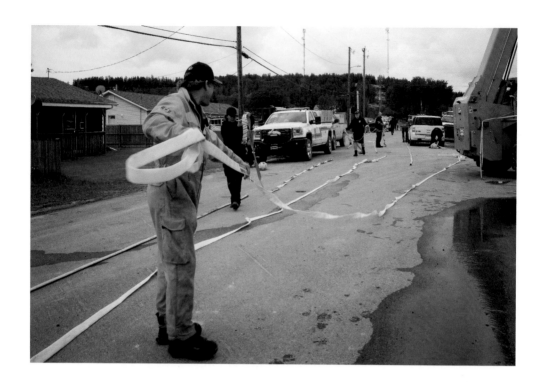

faculty of agriculture at the University of Alberta, said that in order for wildfires to eliminate pine beetles they had to fully burn the trees the beetles were infesting.

"When you burn the trees, you're burning the insects under the bark," said Erbilgin. "When the fire kills the tree it is no use to the beetles because they rely on the fresh source under the bark and it becomes charcoal so they cannot use it . . . The population is significantly declining."

Mountain pine beetles had been devastating forests in areas like Jasper National Park for years. The insect produces a blue-stained fungus that clogs and destroys conductive tissue of a tree, killing it.

The beetle population had already been on a decline, attributed to sustained periods of extreme cold weather that increased the insects' mortality. Erbilgin said that forestry-management activities and the province's push to get rid of

the beetles through burning and tree cutting had also been contributing factors to the decline of the beetle. Now, even more of the population faced elimination due to wildfires.

BY MID-JULY, several provinces began to take stock of a number of lessons learned from the wildfires, with one of the most significant being that many remote communities needed more training to deal with disasters. Highlighting this need were First Nations communities in Lac La Ronge, Saskatchewan, about a 2.5-hour drive north of Prince Albert. Better resources and training were required to ensure the safety of residents, according to emergency crews with the Lac La Ronge Indian Band.

Saskatchewan, at the time, fought 28 active fires, with a core of them located in the La Ronge area. Emergency management representatives for the band said the fires weren't yet causing major disruptions or displacement, but communities were seeking more training in FireSmart, a national program that aims to raise neighbourhood resilience against wildfire. Its provincial programs are managed by the Saskatchewan Public Safety Agency.

"We just need more training [and] more people providing this training, as the province is very stressed out in training the firefighters," said Maurice Ratt, emergency management co-ordinator and fire chief of the Sucker River community with Lac La Ronge Indian Band.

At least two of the fires in this area were not contained and several more were under ongoing assessment. Already at this point in the season, 1.1 million hectares (2.7 million acres) of land had burned, according to the Saskatchewan Public Safety Agency.

The financial strain the wildfire season placed on communities began to be more fully recognized in a number of provinces. Alberta's government offered $175 million to help cover costs for municipalities and Métis settlements recovering from an already unprecedented season.

Nancy Dodds, mayor of the town of Drayton Valley, said her community, which was forced to evacuate residents for more than a week in May, was still assessing the cost of damages, but news of the program came as a relief.

"The Buck Creek wildfire has been one of the most challenging disasters that our community has had to face," Dodds said.

In explaining how the program would work, Stephen Lacroix, managing director of the Alberta Emergency Management Agency, said if a fire started inside the Alberta forest protection area, the provincial Forestry and Parks ministry was responsible for the costs of fighting that fire. Normally, if a fire started outside the protection area (for example, on private land), municipalities would be responsible for paying for firefighting efforts.

But, under the funding envelope, Lacroix said local authorities could now apply for the province to pay up to 90 percent of those outstanding costs.

Alberta Public Safety and Emergency Preparedness Minister Mike Ellis noted there would be no dollar cap on applications, which would be reviewed on a case-by-case basis. The cash could be used to pay for things like additional firefighter wages, staff overtime, and outfitting evacuation centres. It could also help pay to fix infrastructure damaged to keep fires away from communities.

"An example of an eligible cost would be remediating a public park that was torn up to serve as a firebreak, fences cut to allow access to property to fight wildfires or build fire guards, or other property that was damaged to limit the spread of these wildfires," he said.

According to the Alberta Wildfire dashboard, there'd already been 788 wildfires by the second week of July, burning more than 1.5 million hectares (3.7 million acres) of land in that province. About 38,000 Albertans had been forced from their homes via evacuations. Lacroix said fire impacted at least 52 communities, saddling them with costs still being tallied.

"We know that it is the worst wildfire season in Alberta's history," he said, noting that all but two evacuation orders had been lifted at that point.

Drayton Valley-Devon UCP MLA Andrew Boitchenko said that on top of 7,000 residents being forced to flee their homes earlier in the summer, heavy rainfall and rising waters were now posing an additional threat.

"The loss is immeasurable, and healing will take time," he said.

Ellis said it was too early to say whether the $1.5 billion in disaster contingency funding set aside in the 2023–24

provincial budget would need to be reassessed. Municipal Affairs Minister Ric McIver added that the costs of battling the wildfires so far were already approaching $700 million, but noted it was impossible to predict how many floods, fires, or tornadoes were still to strike.

The same disaster recovery program had been used to help communities recover from other major natural disasters, including the 2020 northern Alberta floods, the 2016 fire in Fort McMurray, the 2013 floods in southern Alberta, and the 2011 Slave Lake wildfire. The province noted that the financial assistance was not meant to replace fire insurance coverage, and wasn't available to homeowners, residential tenants, small business owners, landlords, agricultural operations, condominium associations, or not-for-profit organizations.

Support for emergency response and recovery in First Nations communities would generally be covered by the federal government. When Ellis was asked what recourse Indigenous communities and Métis settlements who had been refused fire insurance might have, he said the provincial government was aware of the issue and was in talks with affected communities. "We're working on that right now," he said.

IN BRITISH COLUMBIA, the wildfire situation remained grim. Government officials said firefighters were battling 391 wildfires in the province, in what was now the worst wildfire season on record in terms of land scorched. Bowinn Ma, B.C.'s minister of emergency management and climate readiness, made a renewed plea to residents to be vigilant about not starting fires and to conserve water as the province continued to grapple with serious drought. More than 1.39 million hectares (3.43 million acres) of B.C. land had burned so far this

wildfire season, and as she spoke, 150 homes were on evacuation order, with more than 3,000 on evacuation alert.

"We have already exceeded the most hectares burned in the province due to wildfire for an entire year over the last 10 years, so it is significant and there's likely more to come," Ma said at a news conference on July 19 to provide an update on the province's devastating wildfire season. She noted wildfire officials worried about the weather and how the situation could become worse in the coming days.

"As winds shift today, smoke and cloud cover will clear. These clear skies will increase temperatures, lower humidity, and increase wildfire activity on many of our current wildfires," she said. "We are seeing more climate events—major fires and droughts. This is an extremely challenging time for many people and our communities. It is immensely worrying living day to day with smoke or being [near] a fire or being on an evacuation alert or order."

Ma also acknowledged that wildfire smoke had contributed to the death of a young asthmatic boy in 100 Mile House, an almost 5-hour drive north of Vancouver.

"I know that all of our hearts go out to family and everyone who knew the young man," said Ma. "It absolutely is a reminder that wildfire smoke can present health and safety risks, particularly for those who are very vulnerable. And in some cases that risk is extreme, depending on the vulnerability."

Meantime, the B.C. government reminded people of the serious weather situations gripping the province. Most of B.C. was under drought Level 4 or 5, the highest levels, forcing officials to call on residents to conserve water.

"We are experiencing a serious drought, which may worsen into the fall and summer or even into the next year," said Ma,

who noted that even areas with full reservoirs should be taking measures to reduce water consumption. She said that if low precipitation persisted into the fall and winter, there could be an even more severe drought in 2024.

Dave Campbell, head of B.C.'s River Forecast Centre, said widespread challenges existed throughout the province: "We are not expecting to see huge relief in the short term."

The Canadian Armed Forces, meanwhile, sent a team to Prince George—an 8-hour drive north of Vancouver—to help B.C. firefighters in the emergency operation centre. Another armed forces team assisted at the BC Wildfire service's provincial wildfire coordination centre in Kamloops, and plans were underway to send soldiers to Burns Lake (in northwest B.C.) from Edmonton. These soldiers joined teams from Australia, as well as more than 350 personnel from the United States, Mexico, and New Zealand, and about 2,000 BC Wildfire Service personnel in the firefight.

By the end of the month, the situation grew even more explosive. The Ross Moore Lake fire led to the evacuation of 327 properties from Lac Le Jeune to the outskirts of Kamloops in south central B.C. Another blaze was being held 10 kilometres (6 miles) west of Invermere and 7 kilometres (4.3 miles) north of Panorama Mountain Resort, in the south-eastern part of the province. Fire also neared Cranbrook in the southeast. Crews scorched all the forest and brush around the Cranbrook airport to protect it from the approaching wildfire, which also destroyed homes in the First Nation community

of Aq'am. An out-of-control wildfire from the United States crossed the border into Canada, endangering the community of Osoyoos, with 700 properties handed evacuation orders. Another fire threatened the Port Alberni hospital on Vancouver Island. Thousands of people in these areas received evacuation alerts.

The weather outlook didn't look good for wildfires, said Cliff Chapman, director of wildfire operations for the BC Wildfire Service.

"We're expecting to see hot, dry temperatures," said Chapman. "We did see a little bit of rain come through the province . . . into some of the areas that desperately needed rain, but not all of the areas and not enough rain."

Chapman added that the forecast called for another ridge of high pressure, which was going to bring more dry and hot temperatures, particularly to B.C.'s southern region.

"In the days and weeks to come . . . we may see a significant amount of fires on the landscape, once again," said Chapman.

Disastrously, the prediction proved accurate.

ABOVE When wildfire crisis strikes, provincial borders disappear as firefighters from across Canada work together to control blazes. Firefighters from New Brunswick and Quebec united to fight wildfires near Sturgeon Lake, Alberta. (Photo courtesy Alberta Wildfire)

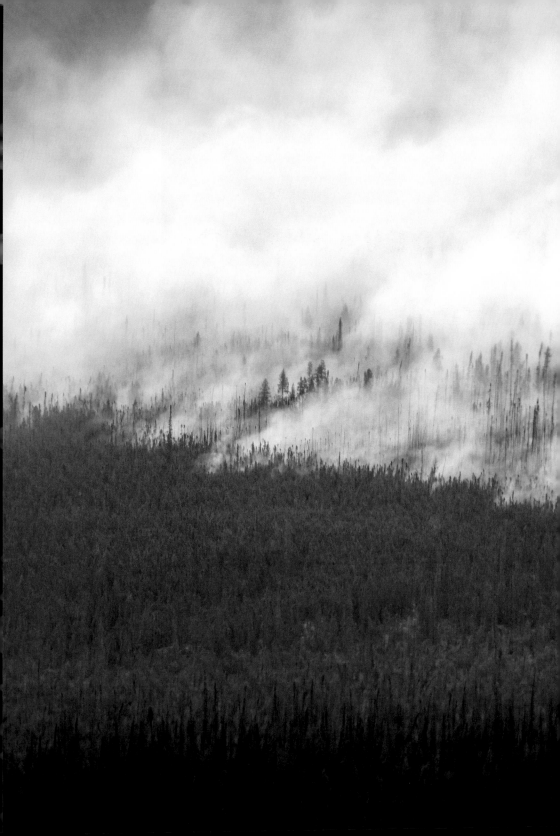

AUGUST

THE DEVASTATION

FOR THOSE WHO live in the Northwest Territories, the forest is part of their DNA—a core part of their character. The forest is where many live, work, and play. People respect the forest and rely on it for sustenance. Over centuries, the NWT's boreal forest has provided fuel, food, shelter, and materials for items such as canoes and cabins, sleds and snowshoes.

Today, still, the boreal forest benefits us all; it's a living filter of black spruce, balsam poplars, and jack pines, taking in carbon dioxide and emitting oxygen. Packed with deciduous trees and conifers, the forest in the Northwest Territories is more than three times the size of the United Kingdom. It's like a lung for the northern hemisphere, nurturing life— except when formidable flames begin jumping from tree to tree to tree.

Those flames began stretching across more and more forest in August. Over 230 fires burned in the Northwest Territories by the second week of August, and some moved dangerously close to several communities. On August 13, a wicked wind began blowing. It violently turned the direction of one fire toward the hamlet of Enterprise, NWT. The hamlet didn't stand a chance.

FACING A wildfire burns south of Enterprise, NWT, on August 17, 2023. (Jeff McIntosh/The Canadian Press)

With reporting in Kelowna by Lori Culbert, Gordon McIntyre, and Derrick Penner.

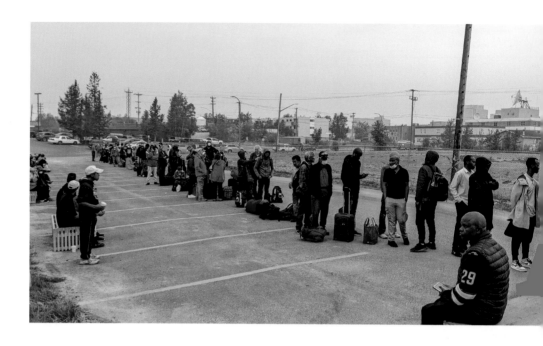

Fire raced toward the community at speeds up to 75 kilometres (46 miles) an hour. Enterprise—once known as a key gateway hub into the north—disappeared into piles of rubble and ash. Flames greedily gobbled up 90 percent of all structures, from homes and garages to businesses and sheds. Firefighters said the blaze was just too hot and too fast.

"The town was gone, pretty much," said evacuee Tanisha Edison. "No buildings left. It was just metal frames melting. You couldn't even read the signs because... when the fire blew through there, they were all melted.

"Trees were like ashes," Edison said after arriving at a fire evacuation centre in St. Albert, on Edmonton's outskirts. She and partner Mason Bruneau drove through Enterprise while undertaking a 19-hour evacuation from her home in Hay River, NWT. Edison was just days away from giving birth.

While the bulk of Enterprise's buildings were destroyed by flames, all 100 or so residents made it out alive, said Blair Porter, the community's senior administrative officer.

"Just a couple days ago, it was a thriving community… now it's all gone. It's pretty devastating."

The hamlet's residents had been evacuated in time. Similar evacuation orders were in effect for Hay River, K'atl'odeeche First Nation, Fort Smith, Salt River First Nation, and Jean Marie River. More would follow for N'Dilo, Dettah, and the Ingraham Trail. But the blazes were unrelenting, and kept rushing toward bigger and bigger communities. By Wednesday, August 16, the Behchoko fire—also known in firefighting circles as ZF015—had the capital city of Yellowknife in its sights. It was time to evacuate a city of 22,000 people—with just one single highway out of town. Leave the city, residents were told—by Friday noon. The blaze approached, just 15 kilometres (9 miles) away.

"Be calm," Yellowknife mayor Rebecca Alty said. "It's time to evacuate."

ABOVE The journey to safety was exhausting for many Yellowknife residents in August. Here, evacuees line up at the Calgary International Airport, awaiting accommodation assignments. (Jim Wells/Postmedia Calgary)

WITH FIRES FLARING across the territory, almost 70 percent of the entire population of the Northwest Territories received evacuation orders.

Evacuation of a city becomes a complex mission. A myriad of special situations requires special handling. Unadopted dogs, cats, and other pets from the Yellowknife SPCA were relocated to Edmonton, via plane. Residents at seniors' facilities and patients at the local hospital were flown into B.C. and Alberta. Continuing-care spaces for 45 evacuees were found in Alberta, while arrangements were made to assist 150 to

ABOVE Yellowknife evacuees who landed in Calgary spent hours in line, first to secure their place on an evacuation flight and then, once landed, to obtain lodging and other services. Here, Jasmine Bonnetrough, 11, waits with her family at the Calgary International Airport. (Jim Wells/Postmedia Calgary)

200 evacuees who'd been receiving home care in the Northwest Territories.

Those without homes also needed to be notified and assisted with their evacuations. NWT premier Caroline Cochrane, a former social worker, personally drove through city streets to find people who otherwise might be left behind.

"My heart's with those people," Cochrane said. "From Thursday morning, from 8:00 in the morning until after midnight—the whole day—I recruited one of the homeless men and we drove through Yellowknife, over and over, to every single place, trying to find people. We were going into places I normally would not go, behind buildings, into bushes," all of which resulted in finding about a dozen people who hadn't left the city.

Evacuating 90 inmates from Yellowknife correctional facilities also required unique protocols. For security reasons, those individuals were quietly relocated to facilities in Yukon and Alberta. It was the second fire evacuation for inmates who'd been moved to Yellowknife when the Fort Smith Correctional Complex and South Mackenzie Correction Centre were previously evacuated.

The evacuation of the city's general population also presented a series of challenges. Not all residents, of course, owned a vehicle, so a schedule of commercial flights, private charters, and military flights was established to get those people to safety. Because Edmonton and area were handling

the bulk of evacuees who were driving, the city of Calgary—300 kilometres (186 miles) or so south of Edmonton—was established as the evacuation centre for most of those leaving by plane.

It would be the largest airlift in NWT history. An estimated 4,000 evacuees were flown into Calgary. Those requiring an air evacuation first lined up at Sir John Franklin High School in Yellowknife to register for a flight, before heading to the airport at an assigned time. The lineup stretched out for blocks and blocks, and many people waited for hours to register.

At the Calgary airport, another registration centre awaited, where evacuees were assigned to hotels and given accommodation, along with information about food, support, and other resources.

"I'm eternally grateful. I shall never forget the kindness and support of Albertans," Premier Cochrane said while visiting evacuees in Calgary.

"Many of the people in the north have never left the north," she said, noting there would be cultural differences and challenges they'd encounter.

One member of the growing exodus of evacuees flooding into Calgary was Darryl Cook, who said upon arrival that he still couldn't believe he was forced to flee his home.

"It was hard to go because northerners have never fled their northern land," said Cook, 56, as he waited in line at the evacuee reception centre at the Calgary International Airport. "We've had each other's backs for thousands of years."

ABOVE About 4,000 people were flown out of Yellowknife and into Calgary as part of that city's massive evacuation of 22,000 people. Here, a sign directs evacuees to services at the Westin Calgary Airport Hotel. (Gavin Young/Postmedia Calgary)

ABOVE When evacuees fleeing the fire in the Northwest Territories arrived at the Edmonton Expo Centre, they were given wristbands that entitled them to a number of benefits, including food and donated items. (David Bloom/Postmedia Edmonton)

Cook, a member of the Dene Nation, said he wanted to stay put and ride out the danger but, amid the heavy smoke blanketing the city of 22,000, "they recommended I fly out."

An expected 26 flights were to touch down in Calgary, bringing many medically compromised evacuees to the city who wouldn't have been able to manage the 14-hour-plus drive from Yellowknife to Edmonton. At the Calgary airport, volunteers provided fruit and bottled water for weary evacuees such as Geraldine Atigitkyoak, who shepherded her four children in search of a hotel room.

"It's emotional, stressful, tiresome . . . My kids are tired, they just want to go to sleep," said Atigitkyoak, 42. But she added her children viewed the evacuation as an adventure, though one whose duration is uncertain. The city offers a variety of activities for families, she noted. "More than where we came from."

Evacuee Mona Durkee and her husband, Art, were still coughing from the smoke they'd inhaled before fleeing from a Yellowknife they described as a ghost town. But she said the exodus was a humbling lesson in patience and gratitude, with the kindness of those helping them in both Yellowknife and Calgary heartening.

"To be received so wonderfully, people in Calgary were amazing. They were here for hours and still carrying on through the night," said Durkee, 68. "We're arriving with just a small pack of clothing, and they're asking, 'How can we help?'"

ABOVE Vehicles line up for fuel at Fort Providence, NWT, on the only road south from Yellowknife, during massive evacuations from that city on August 17, 2023. (Jeff McIntosh/The Canadian Press)

WHILE THOUSANDS OF Yellowknife residents flew out of the capital city, the majority were encouraged to drive themselves to safety. Only one highway provides an exit route from Yellowknife to the southern half of Canada—Highway 3. Within a few hours of the evacuation order being issued, the two-lane highway became jammed. Cars, SUVs, trucks, and trailers formed a line of traffic many miles long.

The distance from Yellowknife to Edmonton is a whopping 1,451 kilometres (900 miles). While the drive can take 14.5 hours on a good day, the traffic—along with smoky skies and fire-rimmed highways—made things much, much worse. Bumper-to-bumper traffic led to a few accidents, while officials urged everyone to stay calm.

Some evacuees recounted stories of driving through flames and falling ash as they made their escape. Officials worked to help those making the trek south. They put pilot vehicles on

the road to help guide travellers through the smoke. They put fuel tankers on the road to help those who ran out of gas.

Truck driver Ron Dodman and his family fled Yellowknife, driving through the burned-out hamlet of Enterprise, NWT, only knowing they were heading to safety in Alberta.

"It's heart-wrenching," said Dodman, outside Edmonton's Expo Centre, having just rolled into the evacuee reception centre. He, like others there, said given the immensity of the wildfire evacuation—including roughly 20,000 people leaving Yellowknife—things had gone smoothly.

"When we left, we didn't know where we were going," said Dodman, noting the disaster was chewing into the family's finances, but they appreciated all the help they'd received. "They are dealing with thousands and thousands at one time, so again, no complaints."

At the Expo Centre, evacuees could receive temporary lodging, food services, clothing, pet daycare, and health care.

Volunteers made sandwiches, organized games for children, and took dogs for walks.

Cheryl Thomas and Craig Thomas arrived in Edmonton from Yellowknife, and they too were impressed with how smooth their evacuation was. But they were prepared.

"I felt we had lots of notice that it could be coming, so we were gassed up, had important papers and stuff, and tried to clear out our fridge and prepare that way," said Cheryl Thomas outside the Expo Centre.

"I think Yellowknife is doing a fabulous job, the City of Yellowknife, and our mayor . . . I'm going to get choked up now . . . and all the other people that are in there making these huge, huge fire breaks.

"I just go with blind faith that things are going to work out. Nobody wants to have to leave their home and think about what may happen, but I prefer to think that we're going to be okay because they are doing a phenomenal job up there."

ABOVE Weary evacuees line up in Edmonton to get assistance with lodging, food, and other essentials after a long drive from the Northwest Territories. Because of the volume of traffic on the road and the smoky conditions—along with occasional roadside fires—a drive that would normally take 14 hours took almost twice as long. (Shaughn Butts/Postmedia Edmonton)

TOP LEFT Waiting for word that your home is safe—and you can return—is one of the most difficult parts of being a fire evacuee. Here, NWT evacuee Audrey Zoe waits for answers in Calgary on August 25, 2023. (Darren Makowichuk/ Postmedia Calgary)

In addition to the Edmonton Expo Centre, additional evacuation centres for Yellowknife residents were set up in Lac La Biche, Valleyview, Whitecourt, and Red Deer. People evacuated from other NWT communities—Hay River, Enterprise, Fort Smith, and K'atl'odeeche First Nation—were directed to evacuation centres in Leduc, High Level, Peace River, the Municipality of Wood Buffalo, Grande Prairie, St. Albert, Lloydminster, and Edmonton, some of which quicky filled up. Free stays at provincial campgrounds were also available for evacuees who preferred to camp on their own.

Facing an evacuation order was a stressful ordeal, said Michel Labine, 63, who was in Fort McMurray after fleeing

the 2,500-resident community of Fort Smith. "We knew this stuff was coming but nobody was prepared for it. We've had these fires burning since May. We've had helicopters in our community all summer long. We've hardly had any rain since the snow melted. They've been working all summer fighting these fires . . . We've suffered a lot of smoke all summer. It's been stressful for people."

The hospitality in towns and cities hosting evacuees made the situation more tolerable, he added. "It's humbling when people walk up to you and want to give you a hug and reassure you everything's going to be okay . . . We're like a big family. Everybody's looking out for each other and hugging each other. Now we're not worried for our lives, we're worried for our community." Fort Smith's August evacuation ultimately lasted more than one month.

Companies, communities, and attractions opened their doors and their arms to make evacuees feel as comfortable as possible. YMCAs in Edmonton and Calgary offered free admission, as did Heritage Park in Calgary as well as Edmonton's Valley Zoo, Muttart Conservatory, and John Janzen Nature Centre. The Edmonton Elks provided free tickets to a CFL game. The Sturgeon Lake Cree Nation held a powwow.

"This summer has been incredibly difficult with wildfire activity across the world. Edmonton is proud to once again welcome and provide care for wildfire evacuees, this time from Yellowknife," city manager Andre Corbould said. "Though a difficult situation brings you to our city, know you are safe here and have our support."

Canadians watched the largest evacuation in N.W.T history occur, but just as thousands crammed onto planes or began an arduous drive south, other fires erupted, demanding

attention—this time back in British Columbia. By August 16, 340 fires blazed across that province; 140 of those were out of control, such as the Gun Lake wildfire, about an hour's drive north of Whistler.

Mother Nature took no pity on the province, scorching the land with searing temperatures. Seventeen communities in B.C. broke heat records on August 15, and the ten hottest places in Canada were all in B.C.—led by the village of Lytton, which hit a blistering 41.4°C (106°F.) It harkened back to conditions 2 years earlier, when in 2021 Lytton's temperature soared to an all-time Canadian record of 49.6°C (121.3°F), just days before a vicious wildfire swept through the village, destroying 90 percent of structures and killing two people.

A cold front, however, was expected to collide with the current system, creating winds and lightning, with—unfortunately—little precipitation expected. Sustained winds could be 40 km/hr (25 mph); gusts could be 70 km/hr (43 mph). Now was the time to have your grab-and-go bag ready.

"We are expecting significant [fire] growth, and we are expecting our resources to be challenged from north to south in the province," said Cliff Chapman, BC Wildfire Service.

PAUL ZYDOWICZ, the chief of a volunteer fire department north of Kelowna, was worried about the strong winds blowing toward Traders Cove on August 17.

He had firefighters staked out in the small community on the west side of Okanagan Lake and more crews stationed on a local forest road to monitor the nearby McDougall Creek wildfire. While airplanes dumped fire retardant in the area, Zydowicz and his team watched as gusting winds whipped up the fire. By 6 p.m., they could see flames marching toward

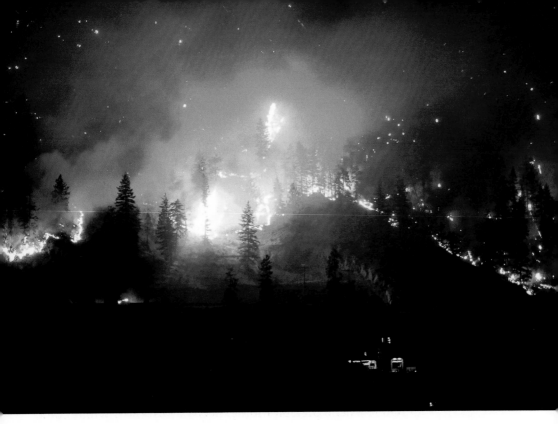

town. They had planned to spend that evening helping residents move flammable items away from their homes, but quickly pivoted and urged people to flee.

"Then the flames started, and they started everywhere all at the same time because it was an ember shower," said Zydowicz, chief of the fire service in Wilson's Landing, just north of Traders Cove.

The department's two dozen on-call firefighters, with their three trucks, suddenly stared down a fast-moving blaze that leapt and grew at a voracious pace.

"We're a pretty small fire department. We have three apparatus, so we tried to do our best, but there was just absolutely no way that we could attack all of it. And as soon as you don't attack it, it spreads," he said. "We fought for as many houses as

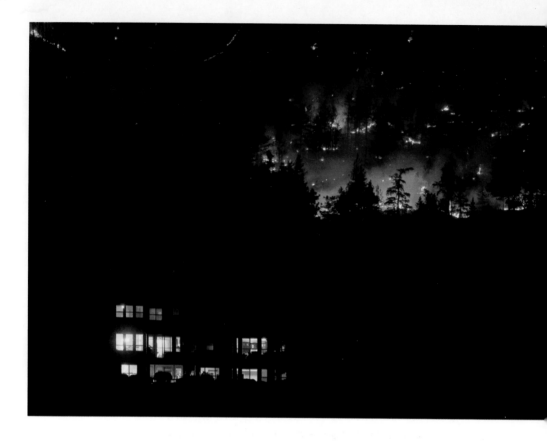

we could. We stopped the flame front and saved probably, I'd say, 65 to 75 percent of the houses in Traders Cove."

That frenzied battle was personal. Of the 24 Wilson's Landing firefighters, 13 lost their homes that night, including Zydowicz.

"I saw my house burn," he said matter-of-factly with the cadence of someone who perhaps had been too busy to grieve that loss yet. "When we were fighting the fires in Traders Cove, we literally had fire personnel with their backs to their house that was burning behind them, and they were fighting the neighbour's, trying to save the neighbourhood."

Zydowicz, whose full-time job is running a riverboat company, knows how to keep accelerants, such as wood piles and

straw mats, away from his residence. But that was not enough to keep the ferocious beast at bay.

"It was extremely, extremely fast. The wind was blowing directly, I mean literally, at my house. It was a wall of fire 100, 125 feet [30, 38 metres] high, travelling 35 kilometres [21 miles] an hour," he said.

"It was surreal. It was watching nature at its worst . . . It just kind of ate my house."

This was the beginning of the worst week during the worst year for wildfires in B.C. history. It led to hundreds of damaged properties and thousands of evacuations across the province, as well as hundreds of firefighters coming from near and far to work together in this crisis.

THE MCDOUGALL CREEK wildfire also swept into West Kelowna, about 13 kilometres (8 miles) to the south. The city's fire chief, Jason Brolund, had spent the day organizing how to attack the blaze and overseeing the command post in the city. Finally, at 2 a.m. on Friday, August 18, he headed home to get a few hours' sleep.

On his way, he stopped in at West Kelowna Estates to check on his firefighters. The scene he saw was "overwhelming." Asking how he could help, a colleague directed him to a street in the subdivision that firefighters had not yet visited.

"I quickly found myself in a pretty tricky battle. I was able to call in our own firefighters to come and help me. And that's when it became real for me that we were surrounded by fire, and it was bearing down on our community hard. And we were all in the fight of our careers," he said.

"I was thinking: If we just had one more fire engine, we could save that house. And if we had one more fire engine,

then we can save those other two houses. And if we had one more, we could get the other ones on the other side of the street. And, you know, of course you can never have enough resources in that situation."

As the night sky glowed fluorescent orange, Brolund knocked on doors to ensure residents had evacuated, and saw firefighters using water from swimming pools to stop the blaze "right before it hits the person's lawn, like inches from the house."

The ferocity of the inferno melted street signs, uprooted large trees, and ripped open propane tanks, blowing them into the woods.

At the same time, Wilson's Landing firefighters continued to attack the blaze as it roared north along Westside Road, hot and smoky work that stretched well into Friday morning. They stayed one step ahead of the flames, protecting small communities such as Pine Point, but were forced to retreat 10 kilometres (6 miles) into their battle when they reached Lake Okanagan Resort.

"The fire chased us out of Lake Okanagan Resort," Zydowicz said.

That morning, boaters posted photos of the historic 217-room resort fully engulfed in flames. Zydowicz and the other firefighters fled north to keep ahead of the fire, but as soon as the wind died down, they returned to the devastated communities along Westside Road.

"We went back in to try and eliminate the houses that were burning and stop other houses from burning," he said.

It was a harrowing 22 hours for a group of people who are paid for firefighting only when they are called out, and who all

FACING More than 10,000 people in West Kelowna were evacuated due to the McDougall Creek wildfire in August 2023. (Photo courtesy Chris Schneider)

have other professions. Some were tradespeople, while others were doctors, lawyers, and entrepreneurs. Two of the firefighters were injured: one had facial burns, the other broke a wrist.

"Those two firefighters, after being treated at the hospital, called me from the hospital and said put me in a next shift please, and preferably earlier," Zydowicz said. "The story here is one that I haven't personally ever experienced in my life, and the dedication of the people that have been here for this is astounding."

He, like most of the other firefighters, moved to a local hotel while his wife and two children stayed with relatives. In addition to losing his house, the fire destroyed $150,000 in boats and other gear for Zydowicz's Northwest River Boats company. GoFundMe accounts were set up for other Wilson's Landing firefighters who lost everything and continued to fight the fire.

About 90 properties were damaged or destroyed by the fire in the North Westside rural area, which encompasses Traders Cove and Wilson's Landing, including a children's summer camp.

Most homeowners obeyed evacuation orders, although a handful had to be rescued after waiting too long to leave.

Another 84 properties were damaged or destroyed in the city of West Kelowna and the Westbank First Nation, along with 4 in Kelowna and 3 in Lake Country.

Brolund, the West Kelowna chief, left the fire's front line to speak at a press briefing at 10 a.m. Friday. He'd been up for more than 24 hours.

"It was a devastating night last night, probably one of the toughest of my career," he said, his voice weary. "We fought 100 years' worth of fires all in one night."

Later that day, Brolund's wife and daughter were evacuated from their family home, and he moved into a nearby hotel. He counted himself lucky, as some of his city hall co-workers slept under their desks in the office.

Friday afternoon, Brolund said, emerged as "one of the most difficult days of firefighting our department has ever faced." They battled three houses burning next to each other, which on "a normal day" would be a massive operation. With the help of the BC Wildfire Service dumping water from above, they stopped the flames from expanding up the hill to devour many more properties.

Also that afternoon, West Kelowna firefighters fought a ground fire threatening a gas storage facility, a mobile home park, and several new condominium developments.

"It's unprecedented. We are not used to fighting wildland fire against six-storey condominium buildings," Brolund said.

IT WAS HOT, DRY, AND WINDY across much of B.C. on that Friday, and the fire crisis was mounting in other areas of the province. Several communities in the Columbia Shuswap Regional District were given evacuation orders as officials said the area was facing "its most devastating wildfire day in history."

The fire risk was so bad that, when cold air whipped up the nearby Bush Creek East fire, it forced the evacuation of a base camp for 400 firefighters west of Adams Lake around 2 p.m. Friday.

Less than 12 kilometres (7 miles) from the camp, the Lower East Adams Lake fire was also picking up intensity near the Interfor Adams Lake Mill, where structure-protection equipment had earlier been set up by the BC Wildfire Service. Two

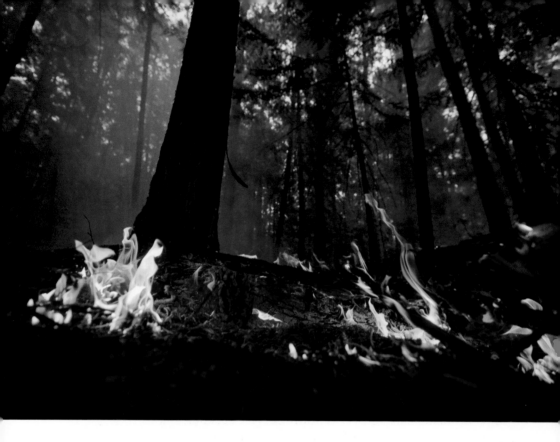

of its crew stayed at the mill that night to ensure sprinklers and other gear continued to work.

"The mill would have had spot fires within hundreds of metres," said Forrest Tower, a BC Wildfire Service information officer.

A major employer in the area, the mill was saved, but other structures in the region were not as lucky. Flames tore south, attacking communities such as Scotch Creek and Celista on the north side of Shuswap Lake.

"It moved 20 kilometres [12 miles] south in under 12 hours, which is extremely [aggressive] for fire behaviour in B.C.," Tower said. "That is a force of nature similar to a tornado, similar to an earthquake or a tsunami."

Structures were destroyed on nine properties and damaged on two properties in the southern Adams Lake area, the

Thompson Regional District said. Losses of up to 100 homes were reported and photographed by residents in Celista and Scotch Creek, but the Columbia Shuswap Regional District had yet to provide an official tally.

The fire that blew into this region "was something I've never seen before," the district's deputy regional fire chief, Sean Coubrough, said in a video posted online.

"When I saw the flames coming that day, it was something bigger than any of us could handle," he said, standing in front of the Celista fire department.

"But the community rallied together, they saved what they could save. It was actually just among the most impressive displays of community spirit I've ever seen."

Tensions, though, began mounting in North Shuswap communities.

Some residents believe a BC Wildfire Service backburn—a fire purposely lit to consume flammable matter on the forest floor—may have contributed to the Lower East Adams Lake and the Bush Creek East fires merging and doubling in size.

Cliff Chapman, the Wildfire Service's director of operations, said the planned ignition was done safely. While he acknowledged the large fire caused "devastation" in Scotch Creek, Celista, and other areas, he said his teams "saved hundreds of properties" by removing forest fuel that could have led to the blaze growing even bigger.

Some North Shuswap residents defied evacuation orders and stayed to protect their properties, complaining that authorities stopped them from leaving to get more fuel and food, while also preventing supporters from bringing supplies in for them.

"Some of us have stayed behind and we're, I'd say we're doing a pretty darn good job," Magna Bay resident Ross

FACING A hot spot from the Lower East Adams Lake wildfire burns in Scotch Creek, B.C., on Sunday, August 20, 2023. (Darryl Dyck/The Canadian Press)

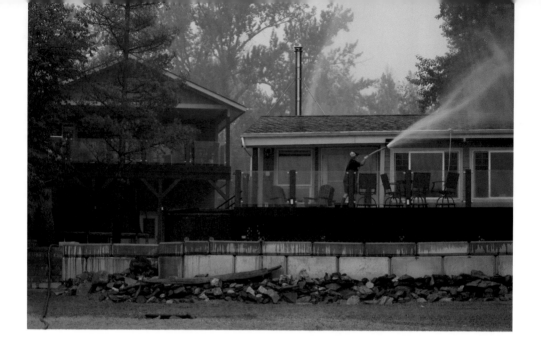

Rathbone told Postmedia. "Our biggest problem right now is. . .
a lack of cooperation from the province."

In his video, Chief Coubrough thanked residents of Scotch
Creek, Celista, Magna Bay, Anglemont, and St. Ives for work-
ing together against the fire, but he implored residents to let
trained firefighters take over the work because of potential
hazards, such as unstable trees and ash pits.

"I want to stress the fact that we've lost structures; people
are hurting, but we haven't lost lives—not yet," he said.

Ron Jules, an elder with the Adams Lake Indian Band,
ignored an order to leave his Chase-area property, stay-
ing behind to keep a sprinkler on his roof. "We can't evacu-
ate because we have to look after our home," he said. "[It's]
all we got."

To make room for evacuees and first responders, the
B.C. government made an unprecedented request to poten-
tial tourists: Don't visit. Tourism accounts for a significant
amount of economic activity in the Okanagan and Shuswap
areas, so a request to limit travel here highlighted the severity

ABOVE People share a moment at the Tselletkwe Lodge, a safe place for Indigenous evacuees and others who'd been displaced due to the wildfires in Kamloops, B.C., on August 22, 2023. (Chad Hipolito/The Canadian Press)

of the situation. A slew of scheduled events was cancelled, including the Penticton Iron Man and Salmon Arm's Roots and Blues festival.

"It is so important, and I want to express my gratitude to people who heard our call. . . not to travel if you don't have to," said B.C. Premier David Eby. "We know it's challenging; we know you had plans. If you were planning on visiting the Okanagan area, visiting fire-affected areas as a tourist, going to a hotel, the fact that you stayed home . . . we're grateful for your understanding and your willingness to stay off the roads."

INDIGENOUS COMMUNITIES WERE also hit hard by this disaster. Despite losing more than a dozen structures on the Westbank First Nation near Kelowna, Chief Robert Louie said that he's thankful for the first responders, police, and volunteers who helped his community.

"This McDougall fire has been a very harrowing experience for everyone," he said. "I'm grateful that there has been no confirmed loss of life that we know of, and we hope that this

remains. It's very devastating for the loss of property and the impact of businesses that has occurred. There's lots of collective grief and high emotions."

As Brolund, the West Kelowna fire chief, drove into work early Saturday morning, he saw two spot fires burning on people's lawns and called fire trucks to douse them. His crews, he said, told him they were seeing similar situations across the whole community, where fire was within "inches" of homes.

He began, though, to feel more optimistic about gaining the upper hand. He recounted a hard-fought, overnight victory achieved by his crews, out-of-town firefighters, and the Wildfire Service: His city's nearly completed $75-million Rose Valley Water Treatment Plant was severely threatened by the flames, but it was saved. "We were not going to let it burn down," he said.

Many residents, however, still had no idea if their houses were still standing or not. Sandy Gilfillan, for one, was unsure if she would have a home to return to in West Kelowna. Despite that, on Sunday, Gilfillan was one of dozens of volunteers feeding fellow evacuees at the Lions/Rotary pancake breakfast and burger lunch outside the Jim Lind Arena, one of three emergency centres providing support to people forced to flee their homes because of wildfires in the Okanagan.

"We served 400 pancakes this morning, and so far I've sliced more than 200 hamburger buns," Gilfillan said mid-day. "I don't know if my house is still standing, but what am I supposed to do, sit alone with my thoughts and worry?"

In 19 years, this was the sixth time Gilfillan had evacuated her home, which sits on the forest's edge. She began packing two weeks ago. Because she has two daughters nearby she had a place to stay, unlike many of those appreciating the hot

meals, pet food, towels, toiletries, and other amenities offered at the West Kelowna centre.

Kelowna's Robert Pullen and his husband, Warren, got a knock on their door on Thursday night from a neighbour with an estimate that they had about 10 minutes to get out of the house as fast-advancing flames from Knox Mountain were approaching.

"What's going to happen now?" Warren said. "Who knows? It happened so quick and, you know what? Tomorrow we might not have a home."

Paul Mann along with his parents, Ruby and Bobby, and their four dogs had been sleeping in their vehicles—a Chrysler 200 and a compact Mercedes SUV—in West Kelowna since evacuating their home next to Shannon Lake on Thursday night.

"We kind of were lost for the first 2 hours. We didn't even know where to call and where to go," Paul said. "We sort of just thought we can make our own plans, but that didn't work."

Like everyone else, they joined the long queue of people awaiting word they could go home.

Also Sunday, Brolund told the daily news conference: "We're now 4 days in. It feels like months. But things are looking better."

The weather had improved, more firefighters were arriving, and a heavy urban search-and-rescue team had come from Vancouver, at Brolund's request.

"We are finally feeling like we're moving forward rather than we're moving backwards, and that's a great feeling for all of us to have. In saying that, make no mistake, there will be difficult days ahead, and we are continuing to prepare and address those," he said.

Firefighters stayed in evacuated neighbourhoods, putting out spot fires and working with public works and utilities companies who controlled water, electricity, and gas to the damaged areas, trying to get the properties safe enough for people to return home.

"It is actually an eerie feeling out there. I've been in your neighbourhood, and there is a real quiet that has descended on the community," said Brolund, whose family also remained evacuated. "There are lots of backyards where the fire has come right to your patio furniture. And it's been stopped there because of the work of the 500 people that are on the ground fighting."

Providing a glimpse into the exhaustion that many firefighters felt by Sunday morning, Lake Country fire chief Darren Lee broke down in tears while thanking firefighters on the front line.

"Sorry, it's been a long few days," Lee said, pausing to compose himself.

"There's people out there working 36-, 48-hour shifts, and they take an absolute beating. They know their families have been evacuated while they're trying to defend their neighbour's home, and they just keep going. They work under incredibly dangerous conditions."

Fighting back emotions, he noted "the fire service had paid a huge price this summer." It was a reference to the firefighters who died while battling wildfires in July.

Lee also acknowledged that it was a tough time for residents who were out of their houses, but said many firefighters were in similar situations and hoped to make "good progress" that day so evacuation orders could be lifted.

"We have people living at the firehall while their families are evacuated. There's some RVs in the firehall parking lot. There's tents set up in classrooms," he said.

WHEN MONDAY DAWNED, Gord Milsom, the mayor of West Kelowna, hadn't had much sleep since he first got news of the fire while visiting Vancouver Island on Thursday. Since rushing home, Milsom spent much of his time talking to evacuees at Royal LePage Place, the city's emergency centre for those forced out of their homes.

"I went to a local pharmacy a couple of days ago, and there was a lady sitting down in the store and she was crying," the mayor said outside the municipality's temporary city hall, a

series of portable trailers adjoining Royal LePage Place. A new city hall was scheduled to be ready to move into in December, but the temporary quarters had already served for 12 years.

"I went over to, I guess, see how she was doing," Milsom said. "She'd just found out, I guess maybe by a neighbour's camera, that she'd lost everything. She had a minute notice to evacuate, she had to go right away because the fire was moving so fast . . . It's devastating."

Another couple he talked to had moved from the Lower Mainland to West Kelowna 3 years ago, built their home, and had just finished adding a suite.

"You know, a place for family and kids," Milsom said. "They'd just hung the blinds up in the suite on Wednesday, and Thursday it was all gone. Our hearts go out to them."

Another man he talked to was out of town when the evacuation order came so wasn't even able to throw a few essentials like a passport into a bag because he wasn't there.

The day did bring one bit of brighter news. The chief of the Popkum fire department, near Chilliwack, was scheduled to become a Canadian citizen that day. Instead of attending the ceremony in person, Walter Roos, originally from the Netherlands, did it over Zoom while taking a break from fighting wildfires near Kelowna. Brolund said it gave him goosebumps to share that story.

Five days into this battle to save communities, the West Kelowna chief said it had become personal for different reasons for different people. The headquarters for the urban search-and-rescue team was in the same building where he went to preschool, and next door to where some firefighters went to elementary school. He witnessed some of those crew members coming off the night shift and going right back out again on the day shift, determined to save their communities.

They were buoyed, he said, by the appreciation of local residents who, through modern technology, could watch firefighters protecting their homes via security cameras installed at their front doors.

"Often you've talked back to us through your doorbell cams and told us that we're doing a good job," he said with a chuckle. "That's new for us."

At 7 p.m. on Monday, Brolund was speaking with Postmedia when cheering and screaming erupted outside his office: It was shift change, and people had lined both sides of the street, yelling to show their support.

"Every fire truck that drives by for the last hour, they're screaming. And that's pretty amazing," he said, his voice raspy. "That's fuel for the guys."

WHILE THE SITUATION in Kelowna improved that Monday, in the North Shuswap firefighters were still "engaged in active and critical firefighting operations," and were unable to attack by air because of thick smoke.

Fire officials continued to plead with residents to leave evacuated areas and to stop moving BC Wildfire Service pumps, sprinklers, and hoses used to protect crucial structures such as the Scotch Creek bridge.

Chapman, with the Wildfire Service, said that as of Monday there were 3,500 local, national, and international people engaged in fire response in the province, with 100 Mexican and 200 South African firefighters about to join as well.

Early Tuesday morning, a new blaze ignited near Anglemont in the North Shuswap, and firefighters near Adams Lake were dealing with unstable trees and falling debris. It was smoky and fires were still "active," but crews worked to stop them from spreading, the Wildfire Service's Tower reported.

From Lee Creek to Magna Bay, firefighters dug control lines to stop the fire from moving down the slope. And 18 sets of "protection equipment" were erected near a number of structures in Sorrento due to a fire burning nearby. Rain fell overnight, which boosted firefighting efforts, but on Wednesday the Wildfire Service's Tower stressed the area's Bush Creek East fire had become the number-one concern in the province. More resources—including up to 150 additional firefighters—were being added to the battle, Chapman said.

"Our focus right now is in basically all the community areas—Lee Creek, Scotch Creek, Celista, Magna Bay—along north shore Shuswap," Tower said Wednesday. "There's weeks left of potential active fire behaviour, I really want to make that clear. But as of right now [it's] in a promising trend of direction."

Back in Kelowna, Zydowicz, the Wilson's Landing chief, estimated his on-call firefighters would be busy for the next month putting out spot fires and making the community safe again.

They will be cheered on by people like Tracy Rullkotter who, while evacuated from her Kelowna home, came to the UBC Okanagan campus to give moral support to firefighters arriving back to their base camp. A sign saying "thank you" hung from the collar of her rescue hound, Lady Bird.

"We wanted them to just be able to have a little bit of joy when they come back," she told Postmedia.

For Brolund, who was a young Kelowna firefighter in 2003 when the Okanagan Mountain wildfire devoured 239 homes there, this firestorm had similar sounds and smells. He also believes, though, that fire departments worked seamlessly

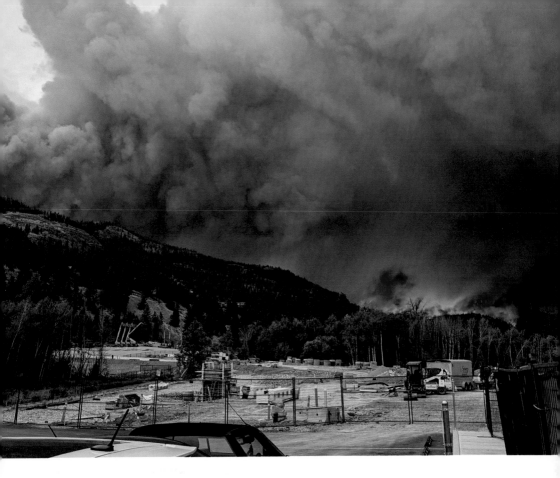

together this time as a united front—perhaps a lesson learned over the last two decades.

"It allows us to be a little bit better prepared, although you can't really ever be prepared for what we've got here," Brolund said.

While many residents in the Shuswap area were still under evacuation order as fires there continued to burn, those in Kelowna started to return home—a new phase that would require recovery and rebuilding, just as many had to do in 2003.

"That scar on our community is going to be here for a long time," Brolund said.

THE HOMES THAT SAT side by side above Okanagan Lake in Traders Cove are where kids learned to crawl before walking, where they grew their first tooth and said their first word. This is where Tiffany Genge and her husband, Hedley, lovingly painted their Heldon Court A-frame steel blue with white trim, and where next door Elizabeth Twyman and her husband, Matthew, built planters for a 1,000-square-foot garden. It's where the teddy bear Matthew once made by hand for Elizabeth sat at the head of a collection of 500 stuffed animals she was crazy about. Now, it had all been wiped out by wildfire.

"When my husband and I first started dating, a couple months into our relationship he came home and gave me a bear he'd made," Twyman said. "And he said, 'Most girls would get a ring, but here's my promise.' He built me a bear, and I've had it for 12 years. It has been through thick and thin. I've mistakenly left it at the airport even and managed to get it back.

"That's probably the one thing I will never really get over, and it seems so silly because it's a teddy bear. But to me, that's the first time he said, 'This is gonna last'—12 years and 2 kids ago, a house—it was the beginning."

The two mothers had gathered up their kids and what belongings they could to evacuate the previous Thursday evening, while the dads made plans to return from work in Fort McMurray, Alberta. (With Kelowna flights cancelled due to the wildfires, a friend drove 8 hours to Calgary to pick them up and deliver them back to Kelowna.)

The McDougall Creek wildfire began on August 16, 10 kilometres (6 miles) northwest of West Kelowna, reaching the regional district of Traders Cove on Thursday. After the evacuation order came Thursday evening, the moms just wanted to get across the lake and be safe, but weren't overly concerned.

Not, that is, until they watched in shock from a Kelowna shopping mall parking lot as flames raced down the mountain "like lava" before jumping the lake and sparking fires in Kelowna and Lake Country.

"At the beginning of the day, it was just another day," Twyman said. She had even babysat a friend's child at her house that morning.

"There was an evacuation alert, but it's just an alert. I was sure it would be fine. [Alerts] had happened before," she said.

Now—a few days later—it was emotionally draining for the two women to tell their story over the course of an hour-and-a-half—there was a box of tissues nearby—but Twyman and Genge felt it was important to share.

"We stood in that parking lot for 3 hours and we watched everything burn," Twyman said through tears.

"We just watched as the flames came down farther and farther," Genge said.

Unable to believe their eyes, they borrowed a pair of binoculars from someone nearby.

"Elizabeth looked through them, put the binoculars down, looked at me, and just started crying.

"She said, 'It's gone. It's all gone.'"

They stayed with a friend that night on Boucherie Road in West Kelowna, safe from the flames, but the smoke became too much by Friday, so moms and kids found a hotel room in Kelowna.

"One minute your logical brain is in control and you can talk about what's happening and everything seems fine, and within the blink of an eye a memory will pass through your head or you'll be talking about something and all of a sudden you can't help but burst out crying," Twyman said. "You're a blubbering mess."

The moms, for instance, were making coffee Friday morn-
ing, talking about how they preferred their familiar coffee
machines back at home.

"And then you're like, 'Oh, shoot,'" Genge said. No more cof-
fee machine, no more home.

Two of Twyman and Genge's Traders Cove neighbours are
first responders—one lost his home, the other's is okay. The
responders sent them photographs of the charred ruins of
their houses, the only thing left standing being a stone chim-
ney on Genge's property, to confirm the women's worst fears.

Their friend Sindy Tucceri, who set up a GoFundMe page
for the families, said, "My two best friends called me [Thurs-
day] to tell me they're watching from the plaza parking lot and
their houses are burning to the ground . . . I told them to come
to my house right away."

That made it four adults and seven children aged seven and
younger under her roof that night.

"These are absolutely my favourite people on the planet. I'm
just glad I had some kind of safe haven and that we could be
together. I wouldn't have wanted to be anywhere else in that
moment," she said. "Nothing can change what's going on, but
the bottom line is friendships, and being there through the
thick and thin, through the worst of it, is more important than
anything."

Genge and Twyman hadn't thought to pack clothes for
themselves—a common oversight made by many evacuees
packing in a panic—and Twyman left behind a $20 bill on her
daughter's dresser that she thought would make a nice sur-
prise when they returned home. But they did save arts and
crafts made by their children.

"I left behind a lot of my stuff, but those memories are here,"
Genge said, pointing to her head with both hands. "But I can

never replace those little things, the 'I Love You Mommys' and the little clay figurines, crap they painted in preschool. I grabbed those. I threw them in the car along with our wedding cake toppers."

The toppers are bobblehead likenesses of she and Hedley.

"I saved those. They're ridiculous."

And her seven-year-old son Jakob wanted to bring his plastic hawk. Genge asked him why.

"He said, 'Because I love it so much.'" That bird, which they affectionately named Phoenix, has now become both families' mascot.

Laughter melded with tears during the long interview, the rollercoaster of emotions Twyman had referred to earlier.

Sleep is fitful when it does come.

Finding short-term rental accommodation, filing insurance claims, and more—all that busy stuff continues. Twyman

and Genge are doing their best to "live in the silver lining." They, too, were once those people who watched natural disasters unfold on their TV screens and think to themselves, 'Oh, that'll never happen to me.'

"When I left my house I had every intention of going home again," Genges said. "Every intention of going home."

AS AUGUST WOUND DOWN, residents in B.C. began returning home, neighbourhood by neighbourhood. Wildfires still burned across the province, keeping people on alert for possible future evacuations, but those who still had houses to return to looked forward to some sense of normalcy.

In the Northwest Territories, fire continued to dart dangerously close to Hay River—just 1 kilometre (0.6 miles) from the town's airport. In Yellowknife, the fire of 166,000 hectares (410,000 acres) had tried to push toward the city, but firefighters resolutely pushed back. They held progression of the fire for several weeks. Airtankers and helicopters flew overhead, splashing loads of water onto the blaze. Soldiers and firefighters feverishly dug fire breaks, while heavy equipment moved earth and trees to create a 10-kilometre (6-mile) control line west of the city. Structure-protection teams worked to prevent loss of buildings in the fire's path. The City of Yellowknife positioned a network of fuel breaks, sprinklers, and other protective measures at the community's fringes. The good news? It all seemed to be working.

With the city of Yellowknife shut down, however, another problem arose. For other still-functioning communities, their main supply hub for everything from prescriptions to pablum was now closed. Cargo planes with supplies for centres north of Yellowknife were organized in Edmonton. Charities

worked to send vital items to essential workers left behind across the Northwest Territories.

Prime Minister Justin Trudeau—on his second trip of the wildfire season to Edmonton to talk to evacuees—shared praise of those he encountered.

"The number of people who have been evacuated—who've been taking these incredibly long drives to get to safety, doing it in a thoughtful orderly way [and] being there to help out each other, look out for each other—is really the best of not just what Canada is, [but is particular to] people who live in the North, where the sense of community and looking out for each other is truly extraordinary."

On the abandoned streets of Yellowknife, RCMP actively patrolled the city, preventing looting and—in one of the few cases where people were not behaving their best during the crisis—looking for suspected arsonists. Spokesman Corporal Matt Halstead said officers had made arrests and were looking for suspects in two separate arsons that had occurred on August 15. One fire was spotted at Fred Henne Territorial Park, near the airport, and was quickly extinguished by an area resident. Four girls were also accused of trying to light a fire in a green space in an east-end neighbourhood.

"It is completely beyond understanding that, in the face of everything going on in the territory and the threat approaching our city, people would actively attempt to start fires and endanger our community members," Halstead said.

Yellowknife evacuees learned they could begin returning to their community on September 6. The long journey home was about to begin.

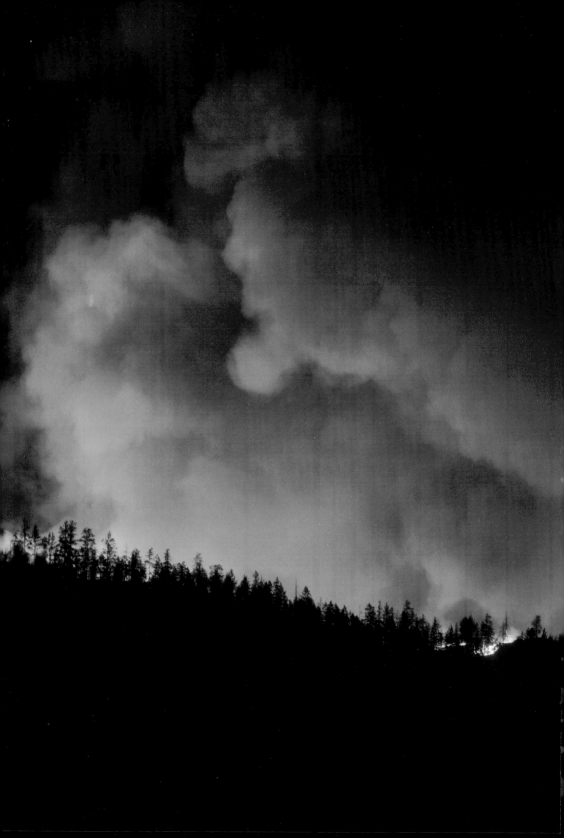

CONCLUSION

THE FALLOUT AND THE FUTURE

CATASTROPHIC WILDFIRES tore through several nations around the globe in 2023. Searing temperatures left many countries battling blazes the likes of which most residents had never seen. In Greece, 355 wildfires erupted in 5 days in August, with the deadliest fire killing 18 people and bringing the death toll to 28. The fire that had chased thousands of tourists from the island of Rhodes in July dispatched smoke and ash across ancient ruins and the capital city of Athens. In nearby Turkey, fires led officials to stop dozens of freighters from using a major shipping lane—a strait linking the Aegean and Black seas—so that firefighting aircraft would have unimpeded access to scoop up water.

France recorded its highest ever temperature for late summer—42°C (108°F) in August—while wildfires forced the evacuation of thousands. Spain struggled with record-breaking temperatures and fires, including those that devoured the Canary Island of Tenerife. Meanwhile, Italy wrestled with multiple ongoing wildfires throughout the summer, particularly in Sicily. Portugal and Croatia also experienced critical blazes.

Other parts of the world suffered, too, with wildfires devastating portions of the North African nation of Algeria, killing at least 34 people. In Asia, Kazakhstan lost 15 people in

FACING The McDougall Creek wildfire burns on the mountainside near houses in West Kelowna, B.C., on August 18, 2023. (Darryl Dyck/The Canadian Press)

large forest fires—its greatest annual death toll. In the United States, 76 large wildfires were burning about 202,000 hectares (500,000 acres) across 15 states at the end of August. And the Hawaiian island of Maui experienced massive devastation and heartbreak in the town of Lahaina, with an August fire destroying much of the town and killing at least 97 people, with 31 others listed as missing in mid-September.

While causes of these global fires vary, a common thread is climate. Maximum temperatures and minimal precipitation left land parched—a significant factor in why many of these fires sparked, why they grew so large, and why they moved so fast.

"It takes very dry, very warm or windy conditions to have very, very big fires as we had this year, regardless of the source," said Yan Boulanger, research scientist at the Canadian Forest Service, Natural Resources Canada. "So, of course, we

have to say that it is because of the weather conditions that those fires spread."

Wildfires in Canada proved no exception in 2023. Drought wrapped its withered arms around the country, leaving conditions ripe for wildfires in almost every province and territory.

"The topic of climate change is a big one, and how it affects the season we're having and the [wildfires'] intensity and duration," said Jennifer Kamau, communications manager for the Canadian Interagency Forest Fire Centre (CIFFC).

The size, intensity, and impact of the 2023 Canadian wildfire season has culminated in a significant contribution of data, providing a case study that will be useful to researchers and organizations studying climate and fire prevention.

The World Weather Attribution initiative studied the early-season wildfires in Quebec to explore the connection between climate and wildfire—one of more than 50 studies it has undertaken on extreme weather events. The study showed human-caused climate change made the weather conditions—that drove the season's extreme fires in Quebec—at least two times more likely. The study's scientists also found that climate change, caused primarily by the burning of fossil fuels, made the fire-prone weather 20 to 50 percent more intense.

"Increasing temperatures are creating tinderbox-like conditions in forests in Canada and around the world," said Friederike Otto, author of the book *Angry Weather* and co-founder of the initiative. In many regions of the world, hotter temperatures are drying vegetation, leading to more flammable conditions that increase the likelihood of wildfires both starting and spreading, according to the World Weather Attribution initiative.

FACING Wildfire smoke gives the setting sun and surrounding sky an other-worldly hue in Calgary on August 16, 2023. (Gavin Young/Postmedia Calgary)

Yan Boulanger, one of Otto's 15 colleagues involved in the study, added, "Climate change is greatly increasing the flammability of the fuel available for wildfires—this means that a single spark, regardless of its source, can rapidly turn into a blazing inferno . . . The word 'unprecedented' doesn't do justice to the severity of the wildfires in Canada this year. From a scientific perspective, the doubling of the previous burned area record is shocking."

A key takeaway from Canada's wildfires is that it demonstrates "climate change really affects everyone's life," said Otto. One only needs to recall the wildfire smoke that blanketed much of North America in summer 2023 to see the direct impact it had on millions of people's health.

"It's a really serious problem that affects us all," she said. "It's not something that's happening sometime in the future to someone else. But we can do a lot to change it."

Another positive Otto points to is that "there's a huge appetite in understanding what's the role of climate change ... Where maybe 5 years ago it was really a conversation that happened for people who were very engaged in environmental issues, now there's a broader interest."

THE CANADIAN WILDFIRES reflect another important link to climate change: Scientists say climate change worsens wildfires and vice versa.

Mohammad Reza Alizadeh, a climate data scientist affiliated with the Massachusetts Institute of Technology and McGill University, said there are three major ways in which climate change influenced the wildfires that ravaged Canada's forests at record rates.

"Climate change has a direct and obvious effect of raising temperatures, which will dry out vegetation more quickly and more completely," Alizadeh told the *Montreal Gazette*.

"The second part of the puzzle is the frequent lightning strikes that start fires. Recent studies show that climate change is significantly increasing the number of lightning strikes that are happening. And the third factor is the windy weather that fans the flames."

Alizadeh said vegetation in the eastern part of the country is less adapted to fires. Because precipitation is usually more frequent in the east during the summer, the vegetation constantly draws moisture from the soil and the atmosphere. When there is drought or a heat wave, the vegetation gets very dry very quickly, and the fires are intense and hard to fight.

FACING Birds fly through the wildfire-caused haze with Eagle Bluffs, Cypress Mountain, in West Vancouver in the background. (Arlen Redekop/Postmedia Vancouver)

By the end of September, almost 18 million hectares (44.4 million acres) had been scorched by wildfires in Canada.

"This is alarming for all of us. We need to take climate change as a serious factor for all those fires," Alizadeh said. "What is unique about what is happening now is that the fires are happening from coast to coast, from east to west. Everywhere there are wildfires.

"I am in Boston, and I can see the smog is affecting all the east coast, moving from Montreal to New York to Boston and even Philadelphia, with all those bad effects in terms of air quality."

Daniel Kneeshaw is co-director of the Centre for Forest Research at the University of Quebec in Montreal and holds the research chair on Resilience and Vulnerability of Forests to Climate Change. He says that while these out-of-control forest fires grabbed headlines this summer, they are only one example of the many negative, and possibly catastrophic, effects of climate change on forests.

"The effect of multiple disturbances . . . new insects moving in, fires, droughts, windthrows [trees uprooted by wind] . . . all these things are increasing at the same time. The scary part of the whole equation is that as we look to fight one battle and while we are focusing on something coming from our right, there are a whole lot of others coming from the left, as well.

"Drought and fire will work hand in hand, and as you get fewer trees, you are pumping less water up into the atmosphere, as well," he said. "If we burn down all our forests, we will be putting less water into the atmosphere to fall back down as rain. So, these kind of feedbacks could have potential repercussions in the long term. Drought leads to more fire, which leads to more drought."

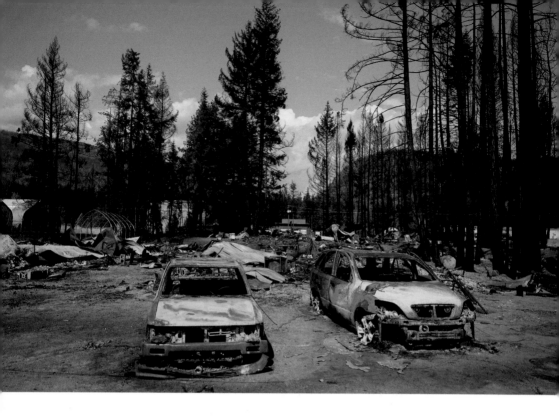

Kneeshaw says none of this is surprising to those who study the climate, and he hopes it lends credibility to what climate scientists have been saying. Wildfires are not just natural phenomena that can be seen as benign, and if policymakers don't act to reduce greenhouse gas emissions substantially, more wildfires are inevitable.

"The fire season will increase as climate change brings earlier springs. Fires will come along with that, starting earlier . . . more intense and lasting longer. So, if you add a month or two to the fire season, you are going to increase the amount of burn. If you add on to that drought . . . multiple whammy. All these things are adding together to make the future look very hot and smoky."

The 2023 wildfire season made climate change very real for West Kelowna, said that city's fire chief Jason Brolund, who was asked to address the Sustainable Development Goals

Summit at the United Nations. "Over $20 million was spent reacting to my fire, not to mention the insurance losses which could be triple that," he said, questioning what could have been accomplished if that money had been spent proactively fighting climate change. "We're spending the money on the wrong end of the problem."

Further amplifying the problem are the emissions from the wildfires themselves. In early August, the EU's Copernicus Atmospheric Monitoring Service said the wildfires had released 290 million tons of carbon. That's well above the largest amount ever before emitted in a single year for Canada—138 million tons in 2014.

CANADA'S MOST DRAMATIC wildfire season in its history demonstrates the importance of moving forward with meaningful action, say experts in this country and around the world.

"It is increasingly evident serious consequences of climate change are with us now," Frank Brown and Russ Feingold said in the *Vancouver Sun* this August. Transformational change is key to addressing this, said Brown (an Indigenous Leadership Initiative senior adviser and Heiltsuk hereditary chief) and Feingold (chair of the Campaign for Nature global steering committee and a former U.S. senator).

Brown and Feingold point to the importance of the Kunming-Montreal Global Biodiversity Framework: "This agreement featured 23 targets to halt and reverse the loss of nature—including as its centrepiece the target to protect at least 30 percent of the planet's land and oceans by 2030. This agreement also included commitments on the funding required, recognizing that ambitious conservation targets only work when complemented by sufficient financing. Specifically, countries agreed to increase international financing from developed countries to developing countries to at least US $20 billion by 2025."

Canada can emerge as a leader in this endeavour the pair says. "Canada is uniquely positioned to help ensure the world delivers on this need. Canada is also well versed in the central role Indigenous nations play in conserving vital ecosystems, and as such should keep working to ensure an increased percentage of all biodiversity financing goes to Indigenous Peoples and local communities, who help conserve 80 percent of the world's biodiversity but receive less than 1 percent of conservation funding."

The impacts of wildfires on Indigenous populations need to be highlighted, as Canada's 2023 wildfire season demonstrated. At one point in the massive evacuations occurring across the country, 75 percent of evacuees were Indigenous.

FACING The wildfire smoke that hung over much of Canada during the summer continued into the fall. Here, the Alberta legislature building is obscured by haze caused by the fires. (Shaughn Butts/Postmedia Edmonton)

"The unprecedented wildfire season this year is incredibly stressful and emotionally devastating for the many affected communities," said Patty Hajdu, Canada's Minister of Indigenous Services. "First Nations communities are often the first to be affected by climate change. As climate-related emergencies become more frequent, Indigenous Peoples are increasingly facing dangerous, destructive, and life-changing situations."

Escalating wildfire seasons may reflect why traditional Indigenous wisdom may be more valuable today than ever before.

"First Nations and Métis people are positioned to play a valuable role in forest management and wildfire suppression," said Doug Cuthand, a member of the Little Pine First Nation and Indigenous affairs columnist for the *Saskatoon StarPhoenix* and the *Regina Leader-Post*.

"The myth that Canadians are rugged individuals living in the Great White North is just that, a myth," he said. "In fact, 80 percent of Canadians live in urban areas, and three-quarters of Canadians live 150 kilometres [93 miles] or less from the American border. This is where our people come in. Our people live in the northern boreal forest and have generations of knowledge about the forests and the animals they support."

Elders notice the changing climate, he said. Where people used to once dig down into muskeg and find ice in the summer—to use for food storage—the ice no longer exists. Animals such as skunks and raccoons are moving further north, deep into the boreal forest. The turkey vultures, once found largely on the plains, have moved north, too, competing with eagles for sustenance, Cuthand said.

"Fire has always been a part of the way of life in the North and a natural part of the life cycle of a forest . . . However, the climate crisis is changing the size and scope of wildfires, and

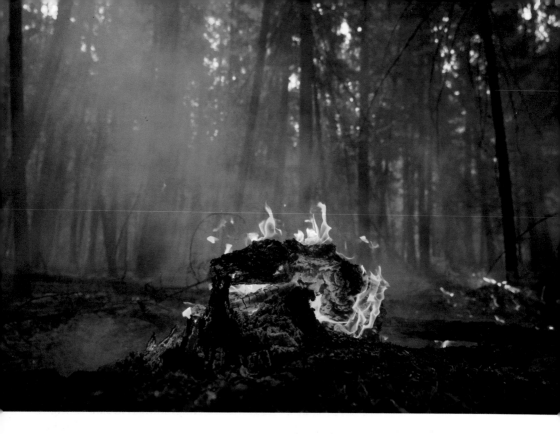

we need to establish a professional firefighting force that includes First Nations and Métis people at all levels."

A 2018 report from the Prince Albert Grand Council for the federal government highlighted the importance of both Indigenous knowledge and hiring more firefighters from the North.

"The PAGC report highlighted the need to hire and train more people from the North and free up valuable resources such as the armed forces," said Cuthand. "Many of our people want to fight fires, but they are not hired and are evacuated south when needed in the North."

As Frank Brown and Russ Feingold note, "Many Indigenous knowledge keepers across cultures remind us of our reciprocal relationships: If we take care of the land, the land takes care of us. We have taken from nature, and now it is time to give back."

TAKING CARE OF THE FOREST provides a vital first step.
Almost 30 percent of the global boreal forest grows in Cana-
da—a beautifully evergreen carbon sink, absorbing carbon
from the atmosphere and helping the world breathe a little
easier. White spruce, black spruce, balsam fir, and jack pine
grow tall here, contributing to both the natural splendour and
economy of the country. Lessons in how this forest should be
managed have emerged from Canada's most recent wildfire
season.

"It is high time to reflect on an ecological approach to for-
est management," said naturalist Briony Penn and ecological
consultant Rachel Holt. The two are advisers to Mother Tree
Network, an extension of the University of British Columbia's
faculty of forestry's long-standing research study called the
Mother Tree Project. They point to two recent government
reports in B.C. that indicate forest-management practices
need to prioritize ecosystem health and resilience over timber.

To better manage the future landscapes for fire need, pol-
icy solutions should include a ban on clearcutting and plan-
tation-style forestry, they said in the *Vancouver Sun* in August.
It's also important that every forest type is managed uniquely,
based on cultural, ecological, and disturbance histories, and
that the ecosystem health takes precedence over timber pro-
duction. The glyphosate used to suppress native plants and
enhance crop growth, for example, can kill certain insects
and soil organisms essential for ecological balance. It can
also cause genetic changes in plants, amphibians, birds, and
humans, while also harming plant growth that would natu-
rally slow the spread of wildfires when they occur.

It would be a "mistake" to blame wildfires on climate
change alone, because forestry practices exacerbate the fires,

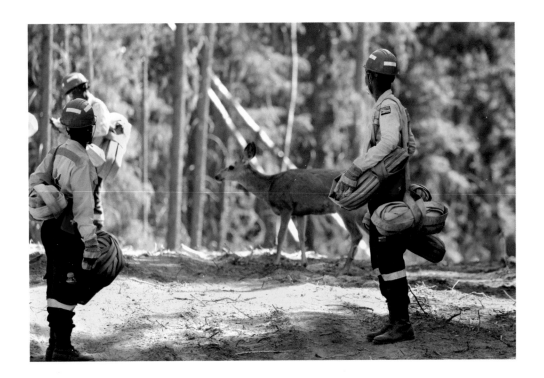

noted Younes Alila, a forestry professor at UBC. He offers the example of replanting "monoculture coniferous species" on logged land. The branches of coniferous trees contain a significant amount of sap, which burns quickly and can help fuel a fast-moving wildfire. These trees also grow more closely together than deciduous trees, which facilitates fire spread. Because they have branches closer to the ground, this also allows fire to jump from the floor of the forest to its canopy more easily.

What occurs in forests after a fire becomes a vital component of the equation. Jesse Zeman, executive director of the B.C. Wildlife Federation, noted in the *Vancouver Sun* in June that a post-fire landscape left untouched creates a natural fire break.

"As new plants and trees grow in, the burned trees that we leave standing are critical for moisture retention and temperature regulation in the soil. In as little as a year, burned areas

sound like a symphony, teeming with life from bugs to birds to bears," Zeman said. "But our forest practices typically prevent natural succession. Instead, we often log areas burned by fire as quickly as possible, because burned trees are harder to cut at the mill after a couple of years."

That leaves behind a barren landscape with stunted native plants due to a lack of soil moisture, Zeman said. This can also exacerbate erosion, flooding, and sedimentation in our watersheds.

Further wildfire impacts in the forest extend to the animals that make their home there. While the larger animals are fast enough to outrun fire, some smaller species may have been killed by flames.

In B.C., Doig River First Nation Chief Trevor Makadahay said the concern was that the huge Donnie Creek wildfire didn't let up, thus depriving animals a reprieve to rest and regroup.

"We're just really worried about all the fur-bearing animals," said Makadahay. Because the flames started in early summer, there were calves and fawns that may not have been able to get out of the way and "that's really disturbing."

The fire also destroyed swaths of important territory for the Blueberry River First Nations. That community had just started working to rehabilitate huge chunks of their territory (north of Fort St. John) from decades of industrial development before the Donnie Creek wildfire struck. Chief Judy Desjarlais was unsure exactly how much of that land was lost.

"It felt like this was just kicking us while we were down," Desjarlais said. "We were just going to get up, and then we were hit again."

Desjarlais said elders watched nervously as important cultural resources burned.

"They're worried about the landmarks to their trapline areas, plus there are certain landmarks in the traditional territory for ceremonial purposes," Desjarlais said.

The fire burned through blueberry and other berry patches that First Nations harvest, also devouring plants used in traditional medicines and that serve as habitat for deer, bison, and moose. Desjarlais said moose in particular is their most important food species, populations of which they had just begun working to restore.

Prolonged smoke inhalation may lead to health issues for some of the animals in the forest. Other animals such as bears may be inclined to leave the devastated forest and travel into people-populated areas in search of food. That was the experience after the Fort McMurray fire in 2016: bear traps were required on some city streets.

Longer term, the fires will affect—some negatively and some positively— vegetation and food sources for some species, as flames can open up the forest floor and encourage new vegetation growth.

ANOTHER IMPACT OF WILDFIRE that can alter animals' habitat—and human communities, too—centres on the risk of flooding. Where fires burn, floods often follow. The environmental impacts of the devastating 2023 wildfire season will be felt well beyond this summer, experts say, pointing to examples from past years where communities hit by fire found themselves facing another disaster months later.

Because burned slopes no longer effectively absorb and moderate rainfall and snowmelt, flooding and landslides are often part of the "cascading effects" of wildfires, said John Clague, an earth sciences professor at Simon Fraser University.

In the months following fire, the baked ground—stripped of its "spongy" understory plants and coated in hydromorphic ash—no longer absorbs heavy precipitation, leading to rapid runoff that can overwhelm creeks and downstream rivers, said UBC forestry lecturer Peter Wood.

Fire also causes a big risk of landslides and debris flows, particularly on steep slopes that have been logged in the past, he explained. In a burned forest, tree roots don't hold the soil, and the runoff causes erosion, filling creeks with sediment, which in turn increases flood risk.

The risk can remain elevated for a long time, said Clague, as the needles, stems, and branches of large trees that once intercepted precipitation and shaded snowy slopes don't do that job anymore.

"That will gradually improve as the forest re-establishes itself, but it takes time," he said. "It's hard to impress how off-scale the amount of land burned is."

Studying Canada's 2023 wildfire season also demonstrates the type of assistance people need during these disasters and what infrastructures should be in place to address them.

"Year after year, the Canadian Red Cross is witnessing an increase in extreme weather events and also concurrent events that are impacting communities across the country," said Conrad Sauvé, president and CEO at the Canadian Red Cross. "By better understanding the risks, we can adopt mitigation strategies in an effort to reduce the severity of emergencies and disasters on people living in Canada and around the world . . . Given that we know the fire weather risk will increase in coming years, the Red Cross will continue to focus on building capacity and building resilience alongside communities across Canada."

Looking at the wildfire season also provides a powerful reminder that countries need to examine how they adapt, said Jonathan Wilkinson, Canada's Minister of Energy and Natural Resources.

"How do we actually better protect critical infrastructure? . . . We are thinking very actively around critical infrastructure, particularly as it relates to the electricity grid," said Wilkinson. "How can you ensure that you are building greater resilience into that?"

His questions fit into a "national adaptation strategy" introduced by the Canadian government earlier in the year, which addressed issues of climate change and extreme weather that can impact people's lives. The strategy will work to create strong and resilient communities, while reducing the impacts of climate-related disasters, protecting nature, building strong infrastructure, and supporting the economy and Canadian workers.

FACING A warning sign about fire risk is seen as smoke from wildfires fills the air, in Kelowna, B.C., on August 19, 2023. (Darryl Dyck/The Canadian Press)

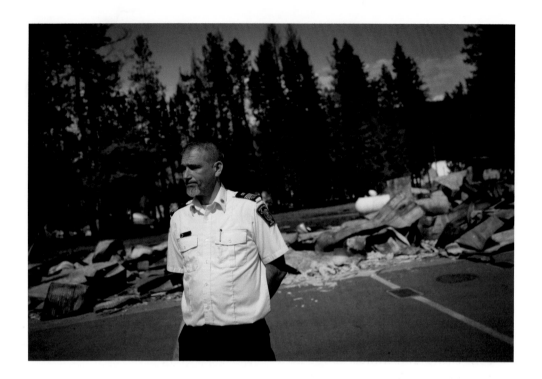

Another impact of the season is the federal government's creation of the "Fighting and Managing Wildfires in a Changing Climate: Training Fund." Ottawa said it would provide $400,000 to the International Association of Fire Fighters in the first phrase of the program, with a goal of increasing wildfire fighting capacity and enhancing best training practices.

"The intent of the training is to enable firefighters within communities to be more effective," Wilkinson said. "But it's also to make it safe, to ensure that they understand very clearly the risks."

The program means up to 325 structural firefighters will receive urban interface wildfire training, which is important. More than 10 percent of Canadians live in this type of interface area, in which urban populations mix with forest. These areas present a potentially dangerous situation, as they throw people and homes directly into the mix if a fire were to occur. The new training was to be provided in addition to another

promise by the federal government to train 1,000 new wildland firefighters in the next half decade, along with 300 Indigenous firefighters and 125 Indigenous fire guardians.

"Canadians from coast to coast to coast have felt the impact of intense wildfires," said Wilkinson, highlighting the need for these programs. "These fires threaten our communities, livelihoods, and our environment."

The wildfire season also gave raise to comments and kudos about how such events should be fought. One of the lessons that can be learned from Canada's wildfire season is that it's crucial a country be well prepared for major fire events, said Friederike Otto, of the World Weather Attribution group. Firefighting efforts in Canada demonstrated lives can be saved in this type of unprecedented scenario, and that's key to any group working in fire prevention around the world.

ABOVE Firefighting agencies are always looking for new ways to attack blazes. One route may be using a swarm of fixed-wing drones carrying water and fire retardant. University of Calgary assistant professor Schuyler Hinman is exploring the idea. (Darren Makowichuk/Postmedia Calgary)

The 2023 wildfire season also opened up a world of hands-on research into best practices. In Alberta, for example, firefighting personnel began experimenting with night vision equipment. They were able to undertake 284 hours of night vision operations for the first time, said Christie Tucker, the information unit manager for Alberta Wildfire.

"We're always learning and evolving and looking at the past and the future in wildfire," said Tucker. "That kind of learning is something that everyone will be doing . . . We'll take opportunities, as much as we can, to share that learning with the rest of the wildfire family and lean on each other."

MARK LIBERA HAS NO formal firefighting experience, but when spot fires threatened his Scotch Creek, B.C., neighbourhood, he and fellow residents jumped into action. The 66-year-old worked in the darkness in the early morning hours of August 19, following the red glow and dousing flames before they spread to homes.

Libera was equipped with a fire pump, purchased on a whim after hearing about an evacuation alert while on a road trip. The system included a 60-metre (65-yard) hose and two 400-litre (105-gallon) water tanks in the cab of his pickup truck, which he refilled using water from an inflatable pool back at his home.

After 36 hours of firefighting on steep terrain, Libera was able to save his home and several others. The only casualties were his steel-toed work boots, reduced to melted rubber as he used them to stamp out glowing embers that fell from the sky and to separate smoking piles of bark mulch.

"I had all kinds of fires threatening me," said Libera, who built his home with his dad in 1997. "When I look at the whole block, this would have gone up for sure if I wasn't here."

In this Shuswap region, 131 structures, including homes, were razed and another 37 were damaged. Libera was one of the many residents in the North Shuswap who defied the province's August 18 evacuation order and stayed behind to fight approaching wildfires into that weekend. He kept in touch with his daughters, who live in Vancouver, on WhatsApp to reassure them he was fine even as they begged him to get to safety.

"I was just heading for the flames," Libera said. "I didn't feel in danger. I felt overwhelmed."

If this were Australia, which relies on a massive army of volunteer "firies" to respond to brush fires across the country, people like Libera might be trained and contracted as volunteer firefighters. But instead, tensions flared between Shuswap residents who said they felt abandoned and officials who scolded people for ignoring evacuation orders. Eventually, the groups began working in improved harmony, but the conflict raised questions about how best these wildfires should be handled.

The 2023 wildfire season has led to calls for more wildfire resources for both prevention and suppression, as the era of climate change predicts more extreme droughts and fires. The problem is no one can agree on what those boosted resources should look like.

Some have called for Ottawa to establish a national wildfire service with trained crews that can be sent wherever needed in the country. B.C. Premier David Eby, however, said he's more in favour of an Australia-style volunteer fire service, even as one wildfire expert questioned the ethics of anyone doing such a dangerous job for little to no pay, especially after a season during which people died fighting wildfires.

In the face of the worst wildfire season on record, and with hundreds of buildings and homes razed by fire in the Okanagan, the BC Wildfire Service used 1,500 firefighters and 700 support staff to conduct fire suppression on the ground and from the air, and to light controlled fires to remove ignition from spreading fires. The fire service also relied on 500 firefighters from Mexico, Brazil, the United States, and Australia.

After B.C. declared a state of emergency on August 18, and with 35,000 people evacuated from their homes in Kelowna,

West Kelowna, and the southern Interior, the military was sent to help with evacuations and to move firefighters and their equipment.

Michael Flannigan, an expert on wildfire behaviour and landscape fire modelling, and NDP MP Richard Cannings, a biologist who represents South Okanagan-West Kootenay, are among the loudest voices calling for the federal government to fund a national wildfire service instead of relying on the military or foreign firefighters.

A national wildfire service, they said, would boost provincial resources during the summer wildfire season and could be tasked to assist with the fuel mitigation work that is key to preventing wildfires in the first place.

"We don't have enough resources," said Flannigan, who notes he's heard the arguments against a national wildfire service. "People say, 'It's a provincial responsibility. It'll cost too much money.' Well, health and safety is a federal concern. And how much money [is Ottawa] spending on disaster relief this year? Every dollar spent on prevention and mitigation saves you 5 to 15 down the road."

Canada's Emergency Preparedness Minister Harjit Sajjan has so far ruled out a federal wildfire service. Sajjan said in a statement that Canada has "sufficient resources to manage the wildfires."

Cannings is disappointed with that take.

"We have to do more than we're doing now because we are going to be overwhelmed, year after year after year," he said.

However, Eby noted the use of skilled volunteers could be more valuable than a centralized firefighting team with no local knowledge.

"It's my understanding that through training and coordination, Australia has been able to leverage volunteer firefighters very effectively," Eby said. "It's something that our teams have looked at already. [C]oming out of this fire season, I think that it's something that certainly a number of people in the Shuswap would appreciate."

After tensions in Shuswap, Eby said the BC Wildfire Service was reaching out to residents who know the local bush, work in forestry, and know how to use heavy equipment to "try to take down the temperature a little bit so that they can all work together on the fires in a coordinated way."

Libera likes the sound of a volunteer wildfire service working alongside BC Wildfire's full-time complement when resources are stretched.

"That would be awesome," he said. "If I was trained, if the government really wants to secure and protect communities, they should equip us with small little units."

Contractor Ross Rathbone, who lives in Magna Bay east of Scotch Creek, said he and a team of local residents worked through a weekend using excavators and pickup trucks loaded with water tanks to attack flare-ups around the small town of Celista. His daughter, Tori, spent her thirtieth birthday on August 21 carrying water jugs up the hill and building fire guards around smouldering underbrush.

"Some of the misconceptions that people have is you're working around these massive flames," Tori said. "It looks like a series of campfire around you with ash and smouldering ground. I think it's important people are not putting themselves in a situation they're not comfortable in."

Her father is convinced the team of local residents prevented the fires from spreading east to his town of Magna Bay and Anglemont. Residents who stayed behind had been ordered by the RCMP to remain in their homes and roadblocks were set up between communities, which Rathbone says blocked crucial supplies.

"If it wasn't for us, you know, not following those rules, I think this community would have been lost," he said.

Currently, when additional help is needed, the BC Wildfire Service calls on contractors in the forestry industry. Career and volunteer municipal firefighters can also be used when fires threaten structures and homes in a populated area, as was the situation in the Kelowna area. BC Wildfire said this year alone it has requested and received assistance from 70 municipal fire departments for structural protection and structure defence work outside of their jurisdiction.

Robert Gray, a wildfire ecologist with decades of experience in B.C., said simply focusing on more firefighters "doesn't help us get ahead of the problem."

Gray doesn't agree with Australia's volunteer fire program "because firefighting is a professional undertaking. It's dangerous."

"You can't expect volunteers to take on that kind of emotional and physical trauma, and not get paid for it," he said. "It's unconscionable."

Gray contributed to the seminal provincial review report "Firestorm 2003," sparked by that year's devastating wildfire season, during which 334 homes and many businesses were lost. Gray said not enough progress has been made on a key recommendation that the province fund wildfire protection plans for communities.

Those protection plans would include work to thin timber, cut underbrush, and remove the lower limbs of trees and woody debris from the forest floor, measures that keep fire on the ground and away from the tree canopy where it spreads more rapidly.

Building capacity to do the fire mitigation work before that fire season, Gray said, will give the BC Wildfire Service more capacity on the response side. The province, he said, can no longer afford to take a reactionary response that will only lead to more scorched earth as future fire seasons promise to be longer and more severe.

"We cannot continue to have fire seasons like this. It's literally killing people."

After the 2023 wildfire season, learnings about global cooperation in firefighting are also on the table, said Jennifer Kamau, communications manager for CIFFC. In this extraordinary season, during which Canada used firefighters from more countries (12) than ever before, there's an opportunity to step back and look at how Canada works with

international partners and how best to continue building those relationships.

"We can't say for sure that the next season will look the same, but should we have more of these, how do we prepare for those? . . . We're still in the thick of it, but [those are things] we'll think about more thoroughly in the after-season debrief," said Kaumau.

When Canadian Prime Minister Justin Trudeau addressed the topic of wildland firefighting, he noted extreme weather events are expected to become more frequent in the coming years due to climate change. That means the country will need to increase resources at many levels.

"There will be more climate emergencies, there will be more major challenges, and so we will have to prepare," he said. "And yes, we are talking about planes, but we are also talking about more training for the population, for firefighters, for the military."

AS FOR THE Canadian wildfire season being a case study in what can happen, experts also point to a wide range of

economic impacts. Lost tourism dollars are just a starting point for areas that usually rely on summer visitors to bolster revenues. Forestry industries were, of course, brought to a standstill in several areas. Some sawmills were forced to close, leading to increased prices of lumber and longer wait times for materials.

Farmers saw land and crops adjacent to forested areas burn, with thick smoke and ash affecting both livestock and crops that were still standing. Winemakers expressed concern the choking haze would taint the taste of their grapes.

Falling ash could also be redistributed in the ecosystem, including waterways, and thus impact fish. Loss of trees due to wildfire also results in more runoff, which can increase sediment in those waterways, again adversely affecting the plant and animal life in those waterways.

Other economic impacts were experienced in energy and mining industries. A number of oil and gas companies curtailed output, or shut down, for a brief period of time as a precautionary measure, when wildfires approached. Cenovus Energy, Tourmaline Oil Corp., Vermilion Energy, Crescent Point Energy, NuVista Energy, and Paramount Resources were among the companies who announced they decreased output from various sites across central and northern Alberta.

"Some of the fires got very close to the rigs," said Ensign Energy Services president Bob Geddes. "There have been some perimeter camps and well-site shacks that have been burned, but nothing on the rigs."

Mining companies also faced closures and risks due to the wildfires. And the impacts of changing climate conditions could play a role in assessing the value of mining projects in the future, experts say. More than a dozen Canadian miners

were forced to temporarily suspend their operations in June due to the ongoing wildfires.

Before assessing the value of a mining project or a company, analysts consider several factors ranging from environmental concerns to geopolitical issues alongside the financial feasibility of operating a mine. Risks linked to climate change, however, haven't tradtitionally been measured, but that could occur more in the future.

"I can see somebody running a portfolio optimization based on climate-change risk, and if you have all your sites in the area that's always going to have wildfires, maybe you will have to think of sites somewhere else outside," said Theo Yameogo, head of Ernst & Young Global Ltd.'s mining section in Canada. "But it's probably going to take time before we see that happen."

Climate change is the third-biggest threat to the mining industry behind geopolitics and environmental, social, and governance (ESG) concerns, according to a survey conducted by Ernst & Young last year. Several miners, including Rio Tinto Ltd. and Toronto-based Wesdome Gold Mines Ltd., had to stop their mining activities as Canada grappled with one of the worst starts to its wildfire season in 2023.

Wesdome, which runs the Kiena gold mine in Quebec, had to shut down for a week and pull its staff out due to the potential risk from the smoke caused by the wildfires. Chief executive Warwick Morley-Jepson said it was the first time he has suspended the mine's operations in the past 5 years, but he doesn't expect it to be the last.

"It's not only the weather. We make provisions in our plans because of other interferences as well," he said. "If climate change is going to start to rear its head as something that happens very frequently, then certainly, we have to build something in those provisions."

He said climate change is influencing the way miners run their business, but the extent of it is something that is hard to predict.

"Do we allocate two-day stoppages per annum to cater for climate change? I don't know, but it might not be a bad idea going forward," Morley-Jepson said. "At the moment, we have stoppages for various things, so do we include climate change causes as one of those? Maybe in time. It's certainly a consideration now."

ANOTHER POWERFUL ECONOMIC PUNCH delivered by the 2023 wildfire season was the individual blow to thousands of Canadians. People lost wages because their employer was closed due to the fires or they themselves were evacuated. Some people lost their small businesses to the flames. Others lost their homes and all of their worldly possessions. While governments offered some assistance and insurance covered some losses, the financial hit proved difficult to recover from, for many.

Other consequences could hit all Canadians in the pocket-book, thanks to a predicted rise in insurance rates. The unusually active forest fire season will probably push up insurance premiums, said Mouvement Desjardins chief executive Guy Cormier. With about 4.3 million policies in force, the Quebec financial-services cooperative is one of the biggest property and casualty insurers in Canada.

"Catastrophes these days are a lot costlier for insurers," Cormier said. "There are new risks—houses that burned down . . . What I see coming in the short term are increases in insurance premiums to mutualize these risks."

Forest fires "have hit all the insurers," resulting in an increase in claims, Cormier added. "Canada doesn't have 75 insurers. There are maybe 15 to 20 insurers, and the risk is spread among these players."

Even so, Desjardins isn't thinking of following in the footsteps of U.S. insurers Allstate and State Farm, which recently stopped selling property and casualty coverage to new homeowners in the wildfire-prone state of California. State Farm cited "historic increases in construction costs outpacing inflation, rapidly growing catastrophe exposure, and a challenging reinsurance market" as reasons for its decision.

"We're not in a frame of mind to stop insuring," Cormier said. "State Farm took a decision in California that was linked to specific issues of legislation, regulations, and risks."

Stubbornly high inflation is one of the reasons insurers such as Desjardins face rising costs when called upon to replace or rebuild destroyed property. New technology built into items such as cars is also compounding the problem, Cormier said.

"With the new technologies, repairing a car today is a lot costlier than it was a few years ago," he said. A side-view mirror "has a camera, a defroster, and a movement sensor. It costs as much as ten times what it cost 5 or 10 years ago. All this puts a lot of pressure on premiums."

As claims increase, Canada's insurers face the prospect of more stringent conditions from their own reinsurers. That, Cormier said, could also drive up premiums.

"There are reinsurers that are going to have new demands," he said. "Either they're going to increase the premiums that they charge us, which will impact individual premiums or our profits, or they're going to introduce new conditions to exclude certain types of risk. Are we going to take on these risks completely, or will we stop insuring certain properties? I don't feel we're there yet. I feel that this is more likely to translate into an increase in premiums."

CONSEQUENCES FROM THIS YEAR'S fire season could also lead to changes in the enjoyment of forested areas in the future. It could mean stricter rules about campfires at certain times of the year, reduced access to sensitive areas, and more regulation around activities that can lead to fires.

"Canadians all love their forests," said Christie Tucker, information unit manager with Alberta Wildfire, noting the country serves up abundant amounts of natural beauty. "I think people are starting to realize more and more, as we experience the kind of year we've just had, the kind of risks that are involved when people go into the forest. It's not just the risk of being in the wilderness; it's the risk that you can cause damage to the wilderness itself.

"I'm hoping what people take away from this season is the realization that wildfire is very close to where we live and that we all have a role to play in preventing fires," she said. It's key that individuals take care and pay attention, while respecting rules and signage regarding closures and fire restrictions.

The season's devastation is already leading to increased awareness of basic fire prevention protocols for all forest users and for those who live in or near the woods. To better prepare Canadians for wildfire season, the Canadian Interagency Forest Fire Centre (CIFFC) shares a program called FireSmart Canada.

"We know that the fires are going to come," said Jennifer Kamau, communications manager for CIFFC. "It's just being better prepared for them, so we have a set of recommendations, suggestions that people can take, ranging from free to things that cost a little bit."

Some homeowners near forested areas have already taken these steps. They've removed the trees closest to their homes to create small fire breaks. They've moved log storage at least 10 metres (32 feet) away from the house. Others have cleaned up potential fuel sources around their homes by getting rid of combustible materials from under the deck, and keeping gutters, roofs, and decks clear of leaves and debris.

The FireSmart Canada program (with accompanying provincial offshoots) hopes its fire prevention program will help people increase resilience to wildfires. It notes there are many recommendations people can follow on a larger scale, too, related to home construction, siding, fences, roofing, and glass.

"You can never be too prepared for wildfires," said Evan Lizotte, fire information officer with the Ontario Ministry of Natural Resources and Forestry. "Homeowners and residents

are encouraged to take action on their property which can reduce their risk to wildland fires. When residents reduce, remove or convert certain vegetation and combustible materials within 30 metres of their home and structures, they can significantly reduce the risk of their structures igniting due to wildland fires. This area is called the home ignition zone."

Getting rid of combustible materials (welcome mats, wood piles and shrubs) in the "immediate zone" of 1.5 metres (5 feet) around a house is the first step, Lizotte said. Following that, residents should look for fire hazards in the area 10 metres (32 feet) around the house, followed by an examination of their property in the extended zone up to 30 metres (96 feet)

away from the structure. This is where residents should remove fallen branches and needles, or consider selectively removing some conifer trees so there's a 3-metre (9-foot) space between them.

The drive to become safer from wildfires highlights one of the practical effects arising from this year's destructive blazes. But at the same time, adverse repercussions continue to mount. It could be years until a final cost is known, resulting from all of the above impacts—on the economy, on industries, on the environment, and on people.

"The impacts of this year's wildfires are likely to be profound in the short, medium and long terms," said research scientist Yan Boulanger.

It is the intangible impacts, however, that will leave the deepest scar. Wildfires like these forever changes one's psyche, said Mary Ann Murphy, an associate professor of sociology and social worker at UBC's Okanagan campus. Murphy led an interdisciplinary team of UBC researchers to study the depth of loss of a home after the 2003 Okanagan Mountain Park wildfire in British Columbia that razed 238 homes and caused 33,000 to flee for safety.

"The financial losses were in the millions, to say nothing of the incomparable cost to our communal sense of safety and security," Murphy said in the *Vancouver Sun* on the twentieth anniversary of that wildfire.

"They [people who lost their homes] had survived . . . [Yet] they mourned about living with the incredible loss of what was more than a structure, as every comfort, every family routine and ritual, everything familiar was turned upside down. They struggled with the loss of something that many people work, sacrifice, tend to, and care about—not a house, but a home—a place that is a reflection of yourself, a welcoming safe harbour, a site of shared history, comfort, celebrations, and traditions."

For the hundreds of victims of the Canadian wildfires, "home" was gone. Where their houses once stood, only rubble remained. But so did their spirit. And resilience. From the ashes, people began to reconstruct their lives, while remembering the wildfire season of 2023—the summer Canada burned.

FACING A few lone buds of green in a landscaped devastated by wildfire in Nova Scotia, May and June 2023. (Photo courtesy Communications Nova Scotia)

SHARING CANADA'S STORIES

DOCUMENTING CANADIAN STORIES that truly matter is a privilege for Postmedia. Providing indispensable and trusted journalism—such as the content found in this book—is at the heart of what we do as a news media company representing more than 130 brands across multiple print, online, and mobile platforms.

The work of 47 Postmedia journalists from coast to coast—and from the following newsrooms—is reflected in these pages. If you'd like to read more from our award-winning journalists, try a subscription for free by scanning the QR code below or going to:

www.nationalpost.com/bookoffer

POSTMEDIA

NATIONAL*POST EDMONTON **SUN** WINNIPEG **SUN**

VANCOUVER SUN TORONTO **SUN**

The Province OTTAWA CITIZEN

CALGARY HERALD The **Mayerthorpe Freelancer** OTTAWA **SUN**

CALGARY SUN REGINA LEADER-POST MONTREAL GAZETTE

EDMONTON JOURNAL SASKATOON STARPHOENIX TELEGRAPH-JOURNAL